# SITING JEFFERSON

# SITING

Based on the exhibition "Hindsight/Fore-site:
Art for the New Millennium,"
University of Virginia Art Museum

LYN BOLEN RUSHTON, CURATOR

# JEFFERSON

## CONTEMPORARY ARTISTS INTERPRET THOMAS JEFFERSON'S LEGACY

EDITED BY JILL HARTZ

University of Virginia Press   Charlottesville and London

University of Virginia Press
Printed in China

*First published 2003*

9  8  7  6  5  4  3  2  1

LIBRARY OF CONGRESS CATALOGING-IN-PUBLICATION DATA

Siting Jefferson : contemporary artists interpret Thomas Jefferson's legacy / edited by Jill Hartz.
         p.      cm.
   Based on the exhibition "Hindsight/Fore-site: Art for the New Millennium," University of
Virginia Art Museum.
   Includes bibliographical references.
   ISBN 0-8139-2183-x (pbk. : alk. paper)
   1. Site-specific installations (Art)—Virginia—Charlottesville Region—Exhibitions.
2. Performance art—Virginia—Charlottesville Region—Exhibitions. 3. Jefferson, Thomas,
1743–1826—Appreciation. I. Hartz, Jill. II. University of Virginia. Art Museum.
NX456.5.S57 S58 2003
709'.04'07—dc21
                                                                        2002015645

Publication of this work was assisted by a grant from the Elizabeth Firestone Graham Foundation.

# CONTENTS

# ACKNOWLEDGMENTS

THE PUBLICATION OF THIS BOOK WILL CLOSE THE THIRD YEAR OF A REMARKABLE PROJECT. Lyn Bolen Rushton, curator of "Hindsight/Fore-site: Art for the New Millennium," proposed the exhibition to me in the fall of 1998. That spring we visited David H. Bancroft, Program Specialist in the Museum Program of the National Endowment for the Arts, who provided both advice and encouragement. The resulting NEA grant was instrumental in the success of our subsequent fund-raising efforts, attracting a broad base of sponsors who provided both financial and in-kind assistance. A complete listing follows: National Endowment for the Arts; Virginia Commission for the Arts; City of Charlottesville; University of Virginia Volunteer Board and Young Friends; Arts Board of the University of Virginia; Philip Morris U.S.A.; The Wachovia Foundation, Inc.; Charles Tanenbaum; University of Miami, Florida; The Elson Foundation, Inc.; McIntire Department of Art, University of Virginia; Fabric Workshop and Museum, Philadelphia; Starr Hill Brewery and Restaurant; Woodberry Forest School; Lexus Law Publishing; Custom Express Cargo; S. L. Tate; Allan H. Cadgene; William Dittmar; Beatrix Ost and Ludwig Kuttner; Gabe and Karen Silverman; Stephen Epstein and Cary Brown-Epstein; Richard Robinson; Mark and Dodd Bronson; John and Jeanne Chamales; Ruth and Robert Cross; Bruce and Sally Nelson; Catherine Dee and Will Kerner; and the participating sites.

We are grateful to Philip Morris U.S.A., whose support of an artist's residency for Rosemarie Fiore enabled us to share the excitement of artistic creation and discovery with at-risk summer school students.

This book would not have been possible without the financial support of The Elizabeth Firestone Graham Foundation and the University of Virginia Press. I am indebted to the Graham family for their belief in this project and in the Museum's ability to realize it, for their contribution of Edgehill Farm as an exhibition site, and above all, for their generosity of spirit. Nancy Essig, former director of the University of Virginia Press, shared my excitement in a

publication that would document and extend the scope of our discussion concerning Jefferson's legacy. Following her advice regarding authors and content has produced a better book than I had anticipated. I thank David Sewell for superb editorial assistance and Martha Farlow for the handsome design of the book.

More than one hundred community volunteers worked hand-in-hand with the artists and site personnel. They helped to create and install the work, maintain the sites, publicize the exhibition, and lead educational programs. This was truly a community endeavor, and I thank all the individuals and businesses that devoted their time, expertise, and materials. Site and volunteer coordinators Annie Herdrich and Mike Alexander performed miracles daily, assuring that the artists were able to create their installations as they envisioned and on schedule. Throughout the summer, Dr. Rushton and the Museum's docents conducted tours of the sites, and the impact of cultural tourism on our local economy became a reality.

The "Hindsight/Fore-site" advisory board played a key role throughout the planning of the exhibition, reviewing proposals, confirming locations, and identifying potential supporters. The board was composed of the following members: John Beardsley, Cary Brown-Epstein, Dean Dass, Nancy Drysdale, Pam Fitzgerald, Gregory Graham, Dave Matthews, Sarah Sargent, Karen Shea, Gabe Silverman, Susan Stein, David Summers, David Toscano, Judy Walker, Shannon Worrell, and Charles Wright. The ongoing guidance of this group, which brought together members representing the arts, business, government, education, tourism, and the University, assured a multifaceted, aesthetically rewarding and intellectually rigorous exhibition.

Tom Cogill's color photographs in this volume beautifully convey the richness and complexity of the artists' installations. Their clarity, scale, and immediacy honor the artists, whose personalities are beautifully captured in Richard Robinson's portraits. Kristi McMillan, our University of Virginia summer 2000 student intern, was instrumental in researching Jefferson and the historical sites as well as the biographical information on the artists. Aviva Dove-Viebahn, an art history graduate student and Museum intern, edited the bios and helped immensely with all areas of the publication.

There is always the danger in organizing a thematic exhibition that the resulting work will be only tangentially related. I thank the artists for taking their task seriously, for finding inspiration in Jefferson's legacy and for translating and extending their discoveries into works of beauty and intelligence. It was a great pleasure and an honor to work closely with Dr. Lyn Rushton on this challenging and rewarding project.

Jill Hartz, Director
University of Virginia Art Museum

# SITING JEFFERSON

# INTRODUCTION

Jill Hartz

On June 17, 2000, the University of Virginia Art Museum opened "Hindsight/ Fore-site: Art for the New Millennium" in twenty locations throughout the Charlottesville region. Earlier that spring the Museum had invited twenty-four artists and arts groups from around the country and the world to create work inspired by Thomas Jefferson's life and time, to make his intellect and our early American history alive and relevant today. For over four months, these works were on view in museums and galleries as well as at sites both public and private, urban and rural. These locations included Ash Lawn–Highland and Montpelier, the homes of James Monroe and James Madison; the Monticello Visitor Center, a short drive from Jeffer*son's own home; and the University of Virginia, Jefferson's university.

What does Jefferson—the man, his writings and actions—offer to new generations of Americans? The answers are complex and open-ended, contradictory, and at times problematic. Jefferson's beliefs and words about slavery, democracy, cultural heritage, conquest, nature, science, agriculture, and family are inextricably bound to his time and its prejudices but they also soar presciently into ours.

While George Washington, the hero-general, is usually called the father of our country, Jefferson, the Renaissance man, helped to create its intellectual foundation. An incessant writer, he penned the Declaration of Independence, Virginia's statute of religious freedom, and numerous other important state papers along with *Notes on the State of Virginia* and thousands of letters to family, friends, and leading public figures. His eloquent writings show an unquenchable curiosity about nearly everything—religion, history, government, agriculture, the arts and architecture, education, and more.

Jefferson had a voracious appetite for learning and its applications. A farmer, he planted new crops and developed alternative methods of production. He acquired three libraries and sold his "great library" to Congress in 1815. He taught himself foreign languages. He commis-

sioned Lewis and Clark to explore and map the unknown territories and send back anything that might be of interest. As president he embodied the doctrine of manifest destiny, more than tripling the size of the continental United States. Familiar with classical buildings, he was the architect of his own home. An inventor, he designed an unusual clock over the entrance inside Monticello, which still works today, and a writing tool that made copies of his letters as he wrote them. A staunch proponent of an educated populace, he founded the University of Virginia to provide an academic training to more citizens than ever before.

Jefferson was also a cultured eighteenth-century gentleman who appreciated the visual and performing arts. Writing to James Madison a year after his arrival in Paris, he said, "You see I am an enthusiast on the subject of the arts. But it is an enthusiasm of which I am not ashamed, as its object is to improve the taste of my countrymen, to increase their reputation, to reconcile them to the rest of the world, and procure them its praise."[1] Jefferson collected sculpture and painting in addition to books, maps, and other items of edification that he felt would refine his and his family's aesthetic tastes and move them closer to personal enlightenment. His library, too, emphasized the arts. In organizing his books according to the three major divisions of knowledge, he gave Imagination or Fine Arts equal status with Memory (or History) and Reason (or Philosophy). He loved music and literature, and he is still regarded as one of our preeminent architects. The neoclassical principles of beauty and order are evident today in his designs of Monticello and the University of Virginia's Rotunda, Lawn, and Pavilions.

Although Jefferson significantly pushed the boundaries in many fields, his views on the fine arts are largely characteristic of his time. His acquaintance with artworks came first from books, including Webb's *Essay on Painting* and Hogarth's *The Analysis of Beauty*, which developed his predilection for neoclassicism. There were no fine art collections in Virginia during the eighteenth century; indeed, the fine arts were considered suspect, a luxury for citizens whose time and industry were better spent building a new nation. "In a country that was still clearing wilderness and fighting Indians, it was preposterous to consider art among the nation's first priorities," as Jefferson scholar William Howard Adams has observed.[2] Perhaps not surprisingly, then, Jefferson placed the practical arts of architecture and landscape design above those of painting and sculpture, although he acknowledged that the latter "could provide inspirational representations of great men and morally instructive happenings"[3] and "give a pleasing and innocent direction to accumulations of wealth which would otherwise be employed in the nourishment of coarse and vicious habits."[4]

While a student at William and Mary, Jefferson had access to fine engravings through books in the university library; the work of mostly undistinguished portrait painters could be seen in many of the leading homes nearby. His firsthand experience with the fine arts broadened greatly with a trip to Philadelphia in the summer of 1766, where he met Dr. John Morgan, a well-traveled collector of fine art and literature. Here he saw original paintings and sculpture, as well as copied masterpieces; displaying such copies was a common practice of the

period, one that Jefferson chose to emulate later in his own selections of sculpture and painting for Monticello.

In 1784, when he was appointed minister plenipotentiary to the court of Louis XVI, Jefferson truly began to refine his taste and became a connoisseur of the arts. His acquisitions for his Parisian home, the Hôtel de Langeac, included paintings by Guido Reni and Joseph de Ribera and sculpture by Houdon, from whom he later commissioned plaster busts of Washington, Franklin, John Paul Jones, Lafayette, and himself, among others. He was part of a cultured society, which visited and admired such artists as Jacques-Louis David and Elisabeth Vigée-Lebrun. The influence of the artist Maria Cosway is well known. Still, in his letters of instruction, Jefferson cautioned his countrymen that the arts of painting and sculpture "are worth seeing, but not studying," and that they were "too expensive for the state of wealth of our country. It would be useless, therefore, and preposterous, for us to make ourselves connoisseurs in those arts."[5]

By the time Jefferson returned to the United States, however, he had become a collector. Among the contents of the crates he shipped back were sixty-three paintings. But Susan Stein, curator at Monticello, cautions: "Jefferson's purpose in collecting art in Paris was entirely didactic."[6] He supported the American artist John Trumbull, who painted *The Declaration of Independence,* and created an edition of etchings (by Asher B. Durand) of the *Battle of Bunker's Hill* and *The Death of Montgomery in the Attack on Quebec.* His plaster casts honored political leaders, philosophers, and other great men. He supplemented his historical and biographical works with engravings of Niagara Falls and the Natural Bridge, supporting his belief in nature's "ability to purify and elevate."[7] Filling Monticello with a wide assortment of paintings, sculpture, prints, and decorative arts, Jefferson documented the major events and people of the new republic and copied the most prized biblical and historical narratives of the Old World to serve as models of morality and enlightenment in the New World. Monticello did more, however, than simply, if luxuriously, represent the best of Jefferson's age. It also embodied his hopes for the future. "If Jefferson believed that the country's economic and cultural immaturity precluded an early flowering of the fine arts, the house and collections of one of its foremost citizens declared that the arts and sciences nevertheless were cultivated and ultimately would flourish as an expression of American independence."[8]

Like most great men, Jefferson himself embodied contradictions. He both distrusted and adored the visual arts. Although he wrote and spoke about the dangers of slavery, he himself owned hundreds of slaves. The third President of the United States, Jefferson chose to omit this honor on his tombstone, electing instead to be recognized as a writer and founder of the University of Virginia. New research strongly corroborates Jefferson's liaison with his slave Sally Hemings, a relationship he never acknowledged. Most comfortable in the role of gentleman-farmer, he was one of the most widely traveled political figures of his time.

While historians analyze Jefferson's actions, words, and paradoxical qualities, people throughout the world continue to find advice and inspiration in his legacy. So, too, artists.

Our museum, like many other cultural institutions, could not resist the opportunity presented by the arrival of a new millennium. The invitation to take stock, to present art that shed light on our past while illuminating potential avenues into our future, was too tempting. And what better touchstone for the University of Virginia Art Museum's millennial explorations than Thomas Jefferson? Jefferson's history is not only a central part of American history; it is also the history of Charlottesville, site of his home and university. His architectural legacy begins here. His writings are preserved in the University's library, his history examined and taught daily by educators at Monticello and the University of Virginia. Local statues commemorate Jefferson and Lewis and Clark. Indeed, Jefferson is an overwhelming presence in this city.

Even for those artists who cannot claim physical proximity as influence, Jefferson remains a powerful figure. In a contemporary art world long concerned with the representation of gender, race, class, and the environment, Jefferson is the mother lode. His paradoxical positions are perfectly suited to a postmodern art world that no longer believes in Ultimate Truth, but enjoys art that sustains multiple interpretations, often simultaneously.

This book documents the University of Virginia Art Museum's millennium exhibition and its related performance events. Most of the works created for this show were ephemeral or site-specific. Consequently, their mark on the landscape is preserved only in these photographs.

Tim Curtis and Rosemarie Fiore set the stage for our inquiry. Curtis's *Visionary Spirit*—a handsome larger-than-life steel greatcoat modeled after one that would have been worn by Jefferson—invited us to fill the hollow shell with our own visions of the great man. Fiore, dressed in Indiana Jones–style accoutrements, excavated an ever-larger hole beside the Monticello Visitor Center in her search for Jefferson, finding his legacy in her videotaped interactions with visitors to Jefferson's home.

Martha Jackson-Jarvis, Michael Mercil, Todd Murphy, Dennis Oppenheim, and Daniel Reeves found fertile subject matter in slavery, the linchpin of the Southern economy, as well as in Jefferson's private relationship with Sally Hemings. Jackson-Jarvis's "winnowing" houses eloquently and emphatically marked the nearly unmarked slave cemetery at Montpelier, James Madison's plantation. Mercil's four-part installation began with a performance piece of *In My Father's House:* a crow shines shoes for free, sitting in the midst of a map noting the cardinal directions, indicative of all America's complicity in slavery. The objects from the installation —references to stereotype or rites of passages in African-American history—were then relocated. When three of the originally requested historic sites were unavailable, those works were displaced to new locations, much like slaves themselves. Murphy's *Monument to Sally Hemings,* a mesmerizing white silk dress atop the downtown coal tower, was also displaced, removed and damaged beyond repair—three times! Reeves's monumental digital painting on the wall of a downtown store rewrote history, positioning Jefferson amid the marginalized peoples of his time, including Africans and Native Americans. Oppenheim's *Marriage Tree,* a

totem of super-enlarged wedding-cake figures in a variety of gender combinations and colors, at Edgehill, Martha Jefferson's home, imparted a note of levity within a plea for tolerance.

Cultural hegemony and the exploration and conquest of new American lands forged uneasy alliances in the work of other artists. The Monacan Indian Community and Living Earth Design Group collaboration, under the direction of artist and landscape architect Dan Mahon, created a twentieth-century burial mound in a county park, on land most likely settled by the Monacans. Plastic toy figures of Native Americans were stomped into the earthwork in a ritual ceremony. Megan Marlatt researched the specimens sent back to Jefferson from the Lewis and Clark Expedition, made possible by the Louisiana Purchase, and created window installations that also questioned this journey of discovery and conquest.

Marlatt's road "paintings" of the shadows of birds at Estouteville introduced the richly expounded "Jefferson and nature" theme. Other works sited at this Jefferson-era estate that examined issues of harmony, interaction, and control of nature were Beatrix Ost's bee colony and glassed-in birds' nests, Dove Bradshaw's copper-embedded stone, and James Welty's welded sculpture of natural and man-made imagery; another was Lucio Pozzi's *A Color Game on Nature* at St. Anne's-Belfield School. Jefferson was, of course, a plantation owner, and the agrarian way of life—and the encroachment of industrialism—were perfectly conveyed in Susan Crowder's *Angus,* a grouping of hay bales covered in tar, and Pozzi's *Parking.*

The strength and foundation of democracy, according to Jefferson, rested on the broad education of its participants. Many of the most thoughtful works in "Hindsight/Fore-site" were inspired by Jefferson's own writings on these subjects as well as his insatiable thirst for knowledge. Susan Bacik's *Benchmark* commanded us to "ask," "tell," and "listen." Robert Winstead and Pete O'Shea's project invited Charlottesvillians to consider building an interactive monument to free speech. Pozzi gave the tools of creation to young children and middle school and high school students. Lydia Gasman re-envisioned Jefferson's library, while Barbara MacCallum appropriated and recycled the conference papers written by her husband, a physics professor at the University of Virginia, into a fur-backed quilt and body forms. Agnes Denes immortalized Jefferson's words and later poetic voices in *Poetry Walk: Reflections—Pools of Thought,* on the University Grounds. Ann Hamilton, too, chose writing for her evocative installation. Projected from turntables in two silk-sewn rooms in a former textile factory, *ghost—a border act* traced the acquisition and concurrent erasure of knowledge.

*Siting Jefferson* continues this conversation about Jefferson's legacy with essays by two noted Jefferson historians—Lucia C. Stanton, Shannon Senior Research Historian at Monticello, and Peter Onuf, Thomas Jefferson Foundation Professor of History at the University of Virginia—and by the president of Jefferson's University, John T. Casteen III. Creating, in effect, a counterpoint to the visual explorations, their writings illuminate not only Jefferson's unprecedented innovations in education and agricultural planning but also the deep and troubling discrepancy between his words and his actions regarding slavery. The essays by John Beardsley, a noted art historian, curator, and member of the exhibition advisory board, and

Lyn Bolen Rushton, curator of "Hindsight/Fore-site," explore the history of site-specific and thematic installations as well as the seemingly limitless aesthetic avenues afforded by a study of Jefferson.

Of the founding of his university, Jefferson wrote that it would be "based on the illimitable freedom of the human mind to explore and to expose every subject susceptible of its contemplation."[9] True to his word, these artists and writers have explored and exposed Jefferson's mind and spirit, often in unresolved and surprising ways. They have found inspiration in his writing and achievements, and with the benefit of hindsight and new facts about his life, they have confronted his now-tarnished, perhaps more human, character. Their questions beget more questions, and the meanings they have found have multiplied, fractured, and reconstituted themselves in new and exciting ways. It is perhaps this continual reassessment of ourselves and our nation that is Jefferson's most enduring influence.

## NOTES

1. Thomas Jefferson to James Madison, 20 September 1785, in *The Papers of Thomas Jefferson,* ed. Julian P. Boyd (Princeton: Princeton University Press, 1950–), 8:434.
2. William Howard Adams, "The Fine Arts," in *Thomas Jefferson: A Reference Biography,* ed. Merrill D. Peterson (New York: Charles Scribner's Sons, 1986), 204.
3. Harold E. Dickson, "'Th. J.' Art Collector," in *Jefferson and the Arts: An Extended View,* ed. William Howard Adams (Washington, D.C.: National Gallery of Art, 1976), 108.
4. Jefferson to Thomas Sully, 8 January 1812, qtd. ibid., 108–9.
5. Jefferson, notes for Messrs. Rutledge and Shippen, 3 June 1788; qtd. ibid., 118.
6. Susan Stein, *The Worlds of Thomas Jefferson at Monticello* (New York : Harry N. Abrams, in association with the Thomas Jefferson Memorial Foundation, 1993), 28. Stein notes that his collection, which included copies of paintings by Raphael and Titian, comprised twenty-six biblical works, seven classical ones, and sixteen biographical ones.
7. Ibid., 37.
8. Adams, p. 214.
9. Thomas Jefferson to Robert Fulton, March 1810, in The Thomas Jefferson Papers at the Library of Congress: Series 1, General Correspondence, 1651–1827: 24 June 1809 to 29 December 1810.

# NEW ART, FAMILIAR GROUNDS

John Beardsley

OUR HISTORIES ARE PROVING ELUSIVE. WE MIGHT BE FORGIVEN FOR ONCE BELIEVING THE fiction that the past could be comprehended through a record of the public deeds and utterances of a few familiar men. Such a past is easier to fathom than the perplexing array of histories that confronts us today: not just of great men, but of great women as well; not just of the privileged and the public, but of the ordinary and domestic; not just of the powerful and triumphant, but of the vanquished and oppressed. Tidy linear chronicles have yielded to multiple and often conflicting narratives that are proving far more difficult to excavate and interpret. "Hindsight/Fore-site: Art for the New Millennium," the University of Virginia Art Museum exhibition upon which the present publication is based, tackled this difficulty head-on. Focusing on one of the original great men, Thomas Jefferson, the exhibition gave artists the occasion to examine an American icon's legacy in light of today's revised and altogether more ambiguous accounts of the past.

The results of this challenge were often inspired: provocative as well as whimsical, wide-ranging and even contradictory. But this is hardly surprising. From a contemporary perspective, the progression of historical events is looking less preordained and more contingent. The familiar paradigm suggesting that the dialectical clash of opposing forces will lead inescapably to synthesis is giving way to something more akin to the model that complexity scientists call "deterministic chaos." While systems exhibit generally predictable behavior, they are far from mechanistic. Many display what is termed sensitive dependence on initial conditions, or the Butterfly Effect. A small change in original circumstances can subsequently be greatly amplified: a butterfly flaps its wings in Singapore and a week later there is a hurricane in Miami.[1] While we might not wish to view our present circumstances as quite so much the expression of accidental forces, both past outcomes and future prospects seem far less inevitable than once we might have thought.

It doesn't seem at all coincidental to me that the emerging complexity of real history is be-

ing matched by the appearance of a soothing pseudo-history. We live in a culture of the pastiche. We don't just visit Disneyland anymore: it comes to us in the form of endless theme parks, themed shops and restaurants, even themed communities, all of which trade on nostalgia for a simpler time that never was. From sea to shining sea, we encounter knock-offs of frontier lands or foreign lands; we ingest historical pabulum from wax museums and audio-animatrons. We live, according to novelist and semiologist Umberto Eco, in "an America of furious hyper-reality," where the real is interchangeable with the fake, where the reproduction replaces not just the original but even the desire for the original. We are surrounded by what cultural critic Jean Baudrillard—following Plato—has called simulacra: copies of a real that never existed.[2]

The spread of pastiche is increasingly global—it might be America's most successful export. It is creating an international mass culture of reproduction that effaces the local and particular features of history and place. Historian Fredric Jameson has described this emerging cultural form as having "a new kind of flatness or depthlessness, a new kind of superficiality in the most literal sense." Lamenting the loss of "real" history, Jameson observes that "we are condemned to seek History by way of our own pop images and simulacra of that history, which itself remains forever out of reach." We are correspondingly unable to organize past, present, or future into coherent experience.[3]

In the face of such confusion, Jameson has issued a call for an aesthetic he terms "cognitive mapping," which would utilize the interpretive and pedagogical dimensions of art not simply to resist homogenization and simulation, but also to recover the particularities of a given time and locale. Such an aesthetic, according to Jameson, involves "the practical reconquest of a sense of place, and the construction or reconstruction of an articulated ensemble which can be retained in memory and which the individual subject can map and remap along the moments of mobile, alternative trajectories." In Jameson's mind, the cognitive map is analogous to "the great Althusserian redefinition of ideology as 'the representation of the subject's *Imaginary* relationship to his or her *Real* conditions of existence.'"[4]

Writing in 1984, Jameson was short on specific examples of what such cognitive mapping might look like, although it was clear to him that the new cartographies would be social as well as geographic. In the years since, we have seen numerous works of art and several exhibitions that together begin to suggest the various ways in which art might participate in "the practical reconquest of a sense of place." Indeed, we can take the "Hindsight/Fore-site" exhibition, along with the larger genre of site-specific, historically generated installation art of which it is an example, as an investigation into such cognitive mapping. However modestly, site-specific installations on historical subjects are imaginative representations of real circumstances. They construct cumulative ensembles that may guide us through the multiple pasts that together have created the present and the possibilities for the future.

"Hindsight/Fore-site" is an exercise in mapping in both literal and figurative senses. Exploring the various installations provides an experience of the sundry physical geographies of

Charlottesville and its environs, of Jefferson's time and ours: public, private, and academic; urban and rural; commercial and residential; elite and vernacular. But it also creates an imaginative connection to those real topographies, and in so doing, confirms that the experience of place is social as well as aesthetic. The histories of Charlottesville and the legacies of Thomas Jefferson have engendered architectural monuments and designed landscapes that are justly celebrated. But their creation is inextricable from social narratives, a fact that several artists in the exhibition took as the point of departure for their work. Martha Jackson-Jarvis, for instance, occupied an unmarked slave cemetery at James Madison's home, Montpelier, for her project, *Markings,* in which small structures suggestive of winnowing houses served to remind us of the distinct and incompletely understood cultures of the Africans who built so much of America in its early centuries. Working with members of the Monacan tribe, Dan Mahon, a participant in the Living Earth collective, built an earthwork in emulation of Native American examples; Megan Marlatt's drawings of specimens collected by Lewis and Clark evoke the expedition's implications both for intellectual discovery and for national expansion. Todd Murphy created paintings and a sculpture that honor Sally Hemings instead of her owner; Daniel Reeves made a mural that evokes Jefferson's physically and philosophically mixed legacy on the matter of race.

Without being heavy-handed, these works celebrate the past without disguising some of its economic, social, and moral conflicts. Such contradictions are not mere present-day imaginings—they are part of the historical record. Jefferson himself, for instance, could insist in his *Notes on the State of Virginia* (1787) that "those who labor in the earth are the chosen people of God, if ever he had a chosen people, whose breasts he has made his peculiar deposit for substantial and genuine virtue," even as he lamented the depletion of natural and social capital caused by the cultivation of tobacco: "It is a culture productive of infinite wretchedness." And he could own slaves even while writing of slavery, "I tremble for my country when I reflect that God is just: that his justice cannot sleep forever. . . . The Almighty has no attribute which can take side with us in such a contest."[5]

Many contemporary histories are frankly partial and conditional; they provide interpretation while admitting its biases and limitations. The sense of looking for something elusive, even indecipherable, characterizes many such narratives. A similar sensibility—in equal parts bewildered and bewildering—is at the heart of several of the most captivating works in this collection as well; it is something Michael Mercil and Ann Hamilton reveal with the utmost seriousness and Rosemarie Fiore with a liberal dose of humor. Mercil's entirely enigmatic performance, *In My Father's House: An Historical Melancholy in Two Acts,* featured the artist in period costume, wearing a crow mask, and wordlessly shining shoes for free. His silence suggested the gulf that separates us from the personages of history, especially those anonymous laborers who filled the ranks of indentured servants and slaves.

Hamilton's equally perplexing installation, *ghost—a border act,* featured two rooms delineated by a semi-transparent fabric, each containing a desk and a chair. On each desk a rotating

projector cast a moving image onto the scrim—and onto the walls beyond that—of a line being endlessly drawn with a pencil onto a sheet of paper. Speakers filled the space with the sound of the pencil moving on the page; this created a kind of white noise. Hamilton's focus was upon a compulsive act of marking that didn't reveal all that much; moreover, because the projectors rotated in opposite directions, each act of marking was simultaneously contradicted by an equal and opposite act. Because the image appeared twice—once on the scrim and once on the surrounding walls—it was nowhere entirely crisp. At the risk of saying too much about so resolutely nonverbal a creation, I would contend that *ghost—a border act* suggested that history is as much erasure as inscription and that what you see in your surroundings—whether past or present—depends on your point of view.

Fiore, dressed in the costume of popular archaeological fiction, dug in the ground at the Visitor Center at Monticello to make her *Meeting Site*. She was excavating for something that was not literally there, the character and personality of Thomas Jefferson. What she found she fabricated: she videotaped a series of interactions with spectators. But her fiction generated something ironically authentic: a record of observations on the meaning of her inquiry into Jefferson's life to a cross-section of visitors to his home.

What is the genesis of site-specific installation art on historical subjects, such as is presented in this project? Artists have been working in the landscape for over a generation now, responding to the specific features of a chosen place. Like landscape architects, they have begun to make art that uses the materials of a particular site to reveal some of its geophysical, topographic, spatial, botanical, and historical characteristics. Some of their works, like Michael Heizer's *Double Negative* (1970)—two enormous excavations that face each other across a curve in a mesa's edge in Nevada—have been meditative in character, intended to draw us into a contemplation of the vast scale and relative solitude of the western deserts. Others, like Christo's *Running Fence*—a fabric line that snaked its way across twenty-six miles of California hills for a few weeks in 1976, passing through pastures, roads, and villages—have been meant to disclose both the physical and political topographies of a landscape, suggesting its literal contours and the shape of the social institutions that govern its appearance.

All of these site-generated landscape projects have been expressions of the artist's visceral and psychological responses to place, something perhaps best revealed in an essay Robert Smithson wrote about the creation of his sculpture *Spiral Jetty* (1970), a fifteen-foot-wide line of black basalt and earth that coils fifteen hundred feet in a counter-clockwise direction into the Great Salt Lake in Utah. Smithson describes how his initial encounter with the place prompted the form of the *Spiral Jetty*. "As I looked at the site," he wrote, "it reverberated out to the horizons only to suggest an immobile cyclone while flickering light made the entire landscape appear to quake." Ringed by distant mountains, the landscape appeared to Smithson to rotate around the still waters of the lake, "which resembled an impassive faint violet sheet held captive in a stony matrix." To Smithson, "this site was a rotary that enclosed itself in an immense roundness. From that gyrating space emerged the possibility of the Spiral Jetty." Smith-

son took pleasure in the fact that his jetty also echoed both microscopic and macrocosmic natural forms: both the spiraling lattice of salt crystals that formed on its rocks and the eruptions of flaming gasses from the sun. "The shore of the lake became the edge of the sun," he wrote, "a boiling curve, an explosion rising into fiery prominence. Matter collapsing into the lake mirrored in the shape of a spiral."[6]

Although Smithson remains arguably the most familiar of the original environmental artists and one of its most eloquent theorists, the language of site-specific sculpture was codified by the sculptor Robert Irwin. In the introduction to his book *Being and Circumstance,* Irwin established several categories of sculpture based on relationship to context: site dominant, site adjusted, site specific, and site conditioned or determined. His terms suggested a spectrum from familiar monuments that overshadow their surroundings to environmental projects that are more integrated with the scale and materials of their settings. At the latter end of the scale, Irwin wrote, "the sculptural response draws all of its cues (reasons for being) from its surroundings. This requires the process to begin with an intimate, hands-on reading of the site." In a manner again analogous to landscape architecture, a quiet contemplation of the character, scale, natural features, history, and uses of a site would lead to a determination of "whether the response should be monumental or ephemeral, aggressive or gentle, useful or useless, sculptural, architectural, or simply the planting of a tree, or maybe even doing nothing at all."[7] Although Irwin insisted he was not implying any value judgments with his terminology, he and other environmental sculptors clearly gravitated toward site-specific or site-generated work.

Irwin's theoretical approach led to radically different works in different contexts: some were steel walls slicing through hilly terrain; others were semitransparent veils of scrim or chain link fencing that created overlapping and intersecting planes of color, light, and texture. Some of his most provocative work was temporary, a condition that came to characterize an increasing amount of site-generated or site-specific art by the late 1970s. By that time, one could speak of "installation art" as a distinct aspect of contemporary sculpture both in and outside the museum. A number of institutions initiated series that showcased temporary projects by artists, while a new exhibition type emerged that featured outdoor installations. In 1971, an international exhibition of outdoor projects was organized in the Netherlands under the title "Sonsbeek 71"; while much of the work was temporary, some survives, including two proximate and related earthworks by Robert Smithson, *Broken Circle* and *Spiral Hill,* as well as an earth, wood, stone, and steel *Observatory* by Robert Morris. A similar show called "Monumenta" was held in Newport, Rhode Island, in 1974; in 1977, "Documenta 6," one of a series of triennial exhibitions in Kassel, Germany, included a selection of commissioned outdoor installations. Ten years after "Documenta 6," a show called "Skulptur Projekte" in Münster, Germany, consisted almost entirely of temporary site-specific work and testified to the completeness with which a concern for context had come to characterize sculpture in the landscape.

For the most part, these exhibitions explored site as a physical phenomenon. But place also has its social dimensions. By the late 1980s, a concern for history had become the focus of some of the more challenging exhibitions of site-specific art. The 1990 exhibition "Die Endlichkeit der Freiheit," conceived for Berlin by artists Rebecca Horn and Jannis Kounellis and playwright Heiner Müller, featured projects on social and historical themes by eleven artists on both sides of the newly reunited city. The following year, the Spoleto Festival USA sponsored a similar project in Charleston, South Carolina, called "Places with a Past." Organized by Mary Jane Jacob, the exhibition eschewed the master narratives and conventional sites of Charleston's glory days and concentrated on excavating some of the city's forgotten stories. For example, David Hammons's version of a local "Charleston single" house bore labels for all the significant parts and revealed the importance of African American carpenters in the design and construction of Charleston's characteristic architecture. Similarly, Ann Hamilton's installation in an abandoned warehouse featured an immense pile of blue work shirts, which evoked the enormous and largely anonymous labor involved in the cultivation of indigo. The Spoleto Festival followed up with a 1997 exhibition, "Human/Nature: Art and Landscape in Charleston and the Low Country," in which twelve commissioned projects created a cumulative picture — or cognitive map — of Charleston's natural and cultural environments.[8] Together, "Places with a Past" and "Human/Nature" provide the clearest precedents in the United States for "Hindsight/Fore-site."

Our artists are creating a new kind of commemorative art. The participants in "Hindsight/ Fore-site," like others who produce site-specific installations on historical themes, are forging a role for themselves in the articulation of public history. By helping to establish imaginative connections to real events in the past, they are aiding in what Jameson termed "the practical reconquest of a sense of place." Approaching history from diverse, even contradictory, points of view, they are helping to create the signposts that might guide us through the perplexing physical and social topographies we inhabit.

We cannot leave the expression of public history to artists alone. Just as we rely on several literal maps — geophysical, political, demographic, economic — to give us a cumulative picture of a given region, so we need contributions from many sources to uncover the historical record, to interpret the present, and to suggest alternatives for the future. But we count on art to be a powerful symbolic and pedagogical language. What is affirmed in the instance of "Hindsight/Fore-site" is that no matter how much art might have changed in outward appearance in the past generation, it still has the power to paint vivid flesh on the clacking bones of history.

NOTES

1. For a primer on complexity theory, see James Gleick, *Chaos: Making a New Science* (New York: Viking Penguin, 1987).
2. There is a growing body of literature on simulation, but Umberto Eco and Jean Baudrillard provide a good

introduction to the subject. See Eco's *Travels in Hyperreality,* trans. William Weaver (San Diego: Harcourt, 1986) and Baudrillard's *Simulacra and Simulation,* trans. Sheila Faria Glaser (Ann Arbor: University of Michigan Press, 1994).

3. Fredric Jameson, "Postmodernism, or the Cultural Logic of Late Capitalism," *New Left Review* 146 (July–August 1984): 60, 71.

4. Ibid., 89, 90.

5. Thomas Jefferson, *Notes on the State of Virginia,* ed. William Peden (New York: Norton, 1972), 164–65, 166, 163.

6. Robert Smithson, "The Spiral Jetty," in *The Writings of Robert Smithson,* ed. Nancy Holt (New York: New York University Press, 1979), 111.

7. Robert Irwin, *Being and Circumstance* (Larkspur Landing, CA: Lapis Press, in association with the San Francisco Museum of Modern Art, 1986), 26–27.

8. For further information on the Spoleto Festival USA exhibitions, see Mary Jane Jacob, *Places with a Past* (New York: Rizzoli, 1991) and John Beardsley, Roberta Kefalos, and Theodore Rosengarten, *Art and Landscape in Charleston and the Low Country* (Washington, D.C.: Spacemaker Press, 1998). Jacob's introduction to *Places with a Past,* "Making History in Charleston," provides a good overview of the history of installation art.

# THOMAS JEFFERSON

## AND THE LIFE OF THE MIND

John T. Casteen III

As anyone who has ever spent any time here knows, Thomas Jefferson still inhabits the University of Virginia. Students, parents of students, faculty, staff, tourists—none leave Grounds without making his acquaintance. About this phenomenon Edwin Alderman once noted, "You cannot speak of Mr. Jefferson around Charlottesville without feeling that he is about to turn the nearest corner."[1]

Mr. Jefferson is so persistent a ghost because we constantly call on him to comment on matters significant—or not. Those of us who speak for institutions that Thomas Jefferson created presume to know his mind in spite of the fact that confusing inconsistencies in his thought are many and well noted in the historical record. These inconsistencies have helped boost Mr. Jefferson's posthumous popularity, allowing him to appeal to political dispositions of all stripes. If Thomas Jefferson, the inveterate politician, were alive today and able to witness his popularity, he would probably think he had died and gone to heaven.

Thomas Jefferson's broad appeal indicates not only his intellectual flexibility, but also the ability of his heirs to entertain opposing views simultaneously. William Jennings Bryan is a case in point. At once populist, agrarian, and religious fundamentalist, Bryan, during his long public career, made a cult of Thomas Jefferson. At home in Nebraska he worked under a large portrait of the great man, and, perhaps as a gesture to political catholicity, two small portraits of Washington and Lincoln. "Thomas Jefferson," he said during a trip to Monticello in 1925, "was the greatest statesman our country produced—then or since." He made this remark just before departing for Dayton, Tennessee, where he spoke as a witness for the state in its case against John Scopes, famously accused of teaching Darwin in a Tennessee public school.[2] Bryan was apparently little troubled by the irony of advocating the Bible as the sole public school text on creation even as he paid homage to the man many think of as America's strongest voice for religious freedom, for the disentanglement of religion and education, and for the advancement of scientific knowledge.

15

In my career as a speaker for a Jeffersonian institution, I have often cited (and will again cite in this essay) Mr. Jefferson's belief in freedom of thought and in the power of science to advance and change human thinking about the world. Still, I have been struck by the fact that my certainty about Mr. Jefferson's belief is matched by an equal certainty in others that he believed something quite different. Once in a letter to parents of students entering the University for the first time, I wrote that Mr. Jefferson "believed that to be educated is to be intellectually and morally autonomous, free of the tyranny of received and unexamined opinion." (I based this observation on various statements by Jefferson. This one from a letter to Peter Carr is representative: "Shake off all the fears and servile prejudices under which weak minds are servilely crouched. Fix reason firmly in her seat, and call to her tribunal every fact, every opinion. Question with boldness even the existence of a God; because, if there be one, he must more approve of the homage of reason, than that of blindfolded fear."[3])

Several weeks later, I spoke to a parent, an engineer by profession, who disagreed with this characterization. He argued forcefully that Mr. Jefferson would never have supposed received opinion capable of tyranny. He would not have wanted to instill intellectual autonomy in the University's students. Rather, this parent insisted, he was a believer in the literal word of the Bible, and would have advocated biblical teachings as the moral basis of the University's curriculum. It was good to hear this, good to turn off the Thomas Jefferson recording in your brain to hear other voices that speak for him.

I expect that the transparent intellect and clear motives that we imagine for Mr. Jefferson come out of a human need for stability and for a vision for the future. The University of Virginia, more than any other institution Mr. Jefferson had a hand in creating, offers the perfect example for both "the great man theory of history" and for Emerson's definition of an institution as "the lengthened shadow of one man."[4] While I am skeptical about how a complex and changing thing like the University of Virginia can be credited to one man, I understand that we make sense of Thomas Jefferson to cope with the complexities of the modern University. Undoubtedly we can say about Mr. Jefferson what Voltaire said about God—if he "did not exist it would be necessary to invent him."

Thomas Jefferson's intellectual starting point may have been in a nonsectarian piety informed by Enlightenment values. His was a faith that posited a deity unknowable to the human mind except for the attribute of reason. According to this philosophical scheme, reason ordered chaotic matter and created the world; post-creation, human beings use reason to sort the complexity of life into systems that promote the well-being of the world. Understanding this as the basis of Mr. Jefferson's philosophy has from the beginning tinged the University community's sense of mission with a certain loftiness. Our logical proof for the morally exquisite nature of our purpose works this way: if the exercise of reason is a God-like activity, then the University of Virginia, in seeking to instill knowledge useful in the exercise of reason, is an institution with something like a divine mission.

Mr. Jefferson's *status* as a thinker is also important to institutions that derive authority

from their connections to him. In the scholarly community there has always been debate about how to classify Mr. Jefferson intellectually—Philosopher? *Philosophe?* Political theorist? Democratic-Republican Party dogmatist? Utilitarian philistine? Those who believe Jefferson a philosopher can with pride point to the intellectual virtue of a nation that made a philosopher president. Henry Steele Commager writes,

> After all, every philosopher knew the Platonic ideal of philosophers as kings, and doubtless approved of it, but France did not place Voltaire on the throne, or England David Hume, or Austria Joseph Sonnenfels, and even Goethe was not allowed to sit at table with the Duke of Weimar until he had been properly ennobled. But Americans did make their philosophers kings: John Adams and Jefferson and Madison, one after another.[5]

The subtext here is that Mr. Jefferson's noble mind ennobles institutions that claim a connection to him. History's judgment about his achievements serves as a pedestal for the institutions that claim a legacy. This legacy has been very good for institutions that claim it. It has caused them to be ambitious, and from ambition have come achievements. This is why we summon Mr. Jefferson into the present. Invoking his name, we remind ourselves of his intellectual and moral legacy. Because of the complexity of the legacy, we can distill from it a set of beliefs to discover principles to live by. In truth, the list is reductionist, but reductionist in an instructive way.

1. Knowledge provides human happiness. Human happiness depends on knowledge for two reasons: first, because knowledge allows people to contribute to their communities in meaningful ways; and second, because it provides for an ordered free society, the necessary condition for human happiness. On knowledge and happiness Thomas Jefferson wrote, "I look to the diffusion of light and education as the resource most to be relied on for ameliorating the conditions, promoting the virtue and advancing the happiness of man."[6]

2. Knowledge makes a person free. Knowledge is power and power allows self-determination. In gaining knowledge, people also gain the perspective and the intellectual tools that enable freedom from social restraints on vocational and intellectual mobility. About this Thomas Jefferson wrote, "The value of science to a republican people, the security it gives to liberty by enlightening the minds of its citizens, the protection it affords against foreign power, the virtue it inculcates, the just emulation of the distinction it confers on nations foremost in it; in short, its identification with power, morals, order and happiness (which merits to it premiums of encouragement rather than repressive taxes), are considerations [that should] always [be] present and [bear] with their just weight."[7]

3. The intellect should be developed in everyone regardless of family background. Based on the notion that all people are equal and are entitled to pursue happiness and determine their own fates, this principle obligates the state to educate all of its citizens: "A system of general instruction, which shall reach every description of our citizens from the richest to the

poorest, as it was the earliest, so will it be the latest of all the public concerns in which I shall permit myself to take an interest."[8]

4. An educated citizenry makes for a free society. Not only is an enlightened citizenry mandated by moral principle, it is instrumental in nation building. Educated citizens, people who are free to think and be as they choose, are uniquely capable, as uneducated citizens are not, of appreciating and supporting democratic institutions. About this Mr. Jefferson wrote, "I know no safe depositary of the ultimate powers of the society but the people themselves; and if we think them not enlightened enough to exercise their control with a wholesome discretion, the remedy is not to take it from them, but to inform their discretion by education. This is the true corrective of abuses of constitutional power."[9]

5. Knowledge should be useful to society. This last principle represents Jefferson's pragmatic and utilitarian approach to education. His aspiration for the University of Virginia was that it be an institution "in which all the branches of science useful *to us,* and *at this day,* should be taught in their highest degree" [italics are Jefferson's]. As President of the American Philosophical Society from 1796 to 1815, he studiously heeded the Society's admonition that its members "confine their disquisitions, principally, to such subjects as tend to the improvement of their country, and advancement of its interest and prosperity."[10]

The first four principles, high-minded and in the American grain, are easy to follow. Not so the last one. Mr. Jefferson's directive that the University teach "useful" knowledge has required some rationalizing. For example, we have been deaf to Thomas Jefferson's academic advice about the study of agriculture: "It is the first in utility, and ought to be the first in respect. . . . It is a science of very first order. . . . In every College and University, a professorship of agriculture, and class of its students, might be honored as the first . . . closing their academical education with this as the crown of all other sciences." Daniel Boorstin notes that Jefferson revised the William and Mary curriculum—Greek and Latin, mathematics, moral philosophy, and divinity—so that it might be more relevant to the needs of the new republic. In addition to agriculture, Mr. Jefferson proposed a curriculum for higher education that would cover law and police; anatomy and medicine; natural philosophy and mathematics; moral philosophy and the law of nature and of nations; fine arts; and modern languages.[11]

To the extent that the University of Virginia's offerings do coincide with Mr. Jefferson's list, I am certain that the coincidence is not out of obedience to his influence, but in response to contemporary cultural demands. Ultimately, it is in this resistance to the tyranny of precedent that we have been the most true to Mr. Jefferson. It his here where his long shadow has been cast.

NOTES

1. Quoted in Merrill D. Peterson, *The Jefferson Image in the American Mind* (New York: Oxford University Press, 1960), 242.
2. Ibid., 260.

3. Thomas Jefferson to Peter Carr, 11 August 1787, *The Writings of Thomas Jefferson*, ed. Andrew A. Lipscomb and Albert Ellery Bergh (Washington, D.C.: Thomas Jefferson Memorial Association, 1903–4), 6:258.

4. Ralph Waldo Emerson, "Self-Reliance," in *Essays: First Series* (1841); quoted in Peterson, *The Jefferson Image*, 241.

5. Henry Steele Commager, *Jefferson, Nationalism, and the Enlightenment* (New York: George Braziller, 1975), 132.

6. Thomas Jefferson to Cornelius Camden Blatchly, 21 October 1822, *Writings* (ed. Lipscomb and Bergh), 15:399.

7. Thomas Jefferson, "Memorial on the Book Duty," 30 November 1821, in *Public Papers of Thomas Jefferson*, ed. Merrill D. Peterson (New York: Library of America, 1984), 476.

8. Thomas Jefferson to Joseph C. Cabell, 14 January 1818, *The Writings of Thomas Jefferson*, ed. Paul Leicester Ford (New York: G. P. Putnam's Sons, 1892–99), 10:102.

9. Thomas Jefferson to William C. Jarvis, 28 September 1820, *Writings* (ed. Lipscomb and Bergh), 15:278.

10. Quoted in Daniel J. Boorstin, *The Lost World of Thomas Jefferson* (Boston: Beacon Press, 1960.), 215.

11. Ibid., 217–18.

# SUSAN BACIK

IVY, VIRGINIA

## Benchmark

2000
Mosaic, steel, glass, 6 ft. x 4 ft. x 4 ft.
Ash Lawn–Highland

Freedom of expression is the cornerstone of participatory democracy; honest and reflective discourse is its lifeblood. *Benchmark* honors our belief in open dialogue and discovery, which is the foundation of any respectful relationship among equals, whether in love, learning, or the rule of law. In this sculpture, the words "ASK" and "TELL" are written in mosaic on two facing benches. "LISTEN" is etched into the sky-blue glass of the screen, which frames the space. In observing the space thus defined—perhaps stepping into it, perhaps sitting down, perhaps talking with another there—a viewer is invited to become a participant in the kind of civil exchange that is a benchmark of Jeffersonian tradition. This sculpture creates an environment, both physical and psychological, which celebrates a continuation of that tradition as a touchstone for the new millennium.

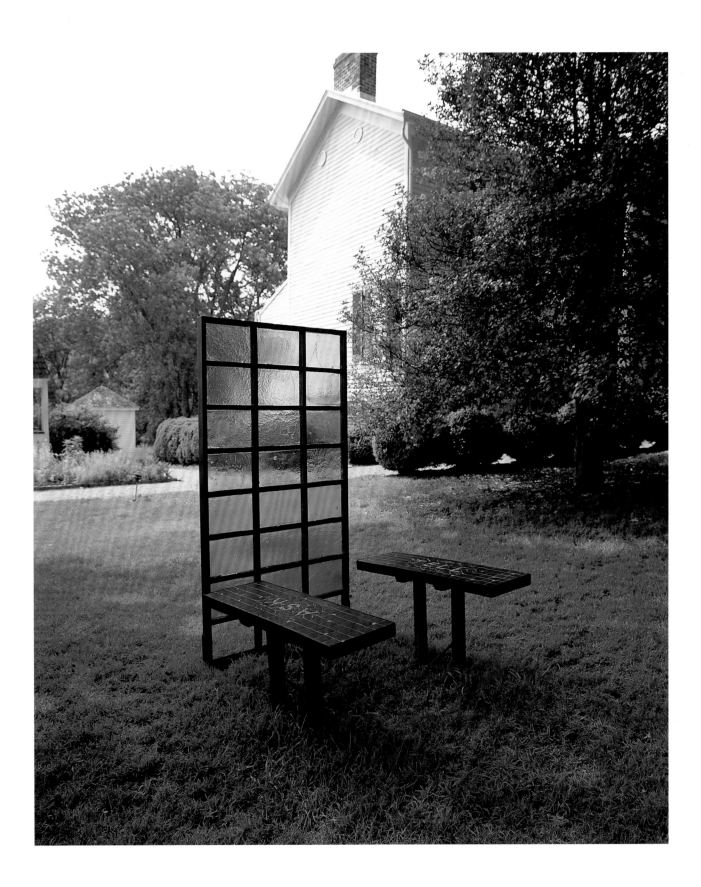

# AGNES DENES

NEW YORK, NEW YORK

## Poetry Walk: Reflections—Pools of Thought

2000

20 granites, 4 ft. x 5 ft. each, carved with poetry,
embedded into the Grounds at the University of
Virginia, 535 ft. x 60 ft.

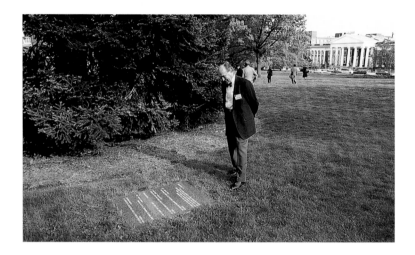

*A public art project sponsored by the Arts Board, the University
of Virginia Art Museum, and a private donor.*

THE POWERFUL TOOLS OF ARTISTIC VISION, IMAGE AND METAPHOR BECOME EXPRES-
SIONS OF HUMAN VALUES WITH PROFOUND IMPACT ON OUR CONSCIOUSNESS AND COL-
LECTIVE DESTINY.                                              —Agnes Denes, 1989

*Poetry Walk* is a true millennial project. It brings the essence of many great minds into one
work of art and preserves the past for fruitful use in the present and the future. This kind of
undertaking is necessary; otherwise the past sinks into dusty memory without use or rele-
vance. Human values expressed with passion create a lasting impact: they enlighten, moti-
vate, and inspire young minds. Jefferson designed his University for the students to come to-

gether and exchange ideas. He even laid out the various subjects he wanted instructed. I carved his concept into stone.

I believe in uniting disciplines alienated by specialization, thus creating a powerful overview. I've included not only poetry but quotes from philosophers, political thinkers, and other social critics whose writings in this excerpted form read like poetry. The selection of writings from the past rings forth poignant moments from the history of Virginia with relevance to the whole country. I have included one stone for my manifesto that announced my commitment to this new form of art three decades ago. This new art form, whose integrity and high ideals serve others, not the self, brings people and neighborhoods together in friendship and common goals, speaking to people of all ages and backgrounds.

The issues touched on in my work range from individual creation to social consciousness. I map human evolution and create social structures and

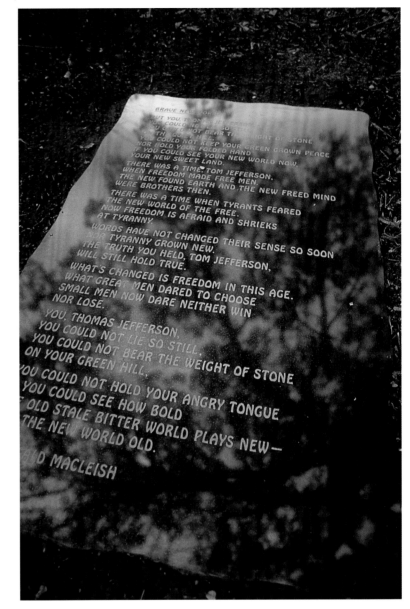

metaphors for our time. By planting forests on abused land and growing fields of grain in megacities, or giving a face to history, the work addresses global concerns. It affirms our commitment to the future well-being of ecological, social, and cultural life on the planet and benefits future generations with a meaningful legacy.

*Poetry Walk* is a happy place. The carved granites with their high polish reflect the trees, swaying branches, and people. As they sit in the ground surrounded by green grass or brown soil, the stones resemble pools of moving water with the words floating on top. They will make many students think, ask questions, talk to each other, and see the world in a better light. If so much wonder can come out of people, dead or alive, what is there to worry about?

# BARBARA MACCALLUM

CHARLOTTESVILLE, VIRGINIA

## The Metamorphosis of a Scientific Article Produced in Mr. Jefferson's University in the Year 2000

Paper, fur, thread, glue, audiotape

Frank Ix Building, 531 Ware Street

*Lighting design by Rowena Halpin*

My work deals with the creative process in science and art. This installation has evolved as a collaborative relationship with my husband, who is a physicist. I recycle his published papers, giving new existence to the detritus of science. The work is also a portrait of our marriage, our creativity, and our aging. Although the metaphor of the quilt has served this purpose well, it is the subversive element that removes the work from the traditional quilt and sharpens its edges. The matted fur backing of the scientific papers, the negation of the comfort of warmth by the intrusion of violence, the reference to body parts and the distressed, destroyed, and layered surfaces reflect the drama of life.

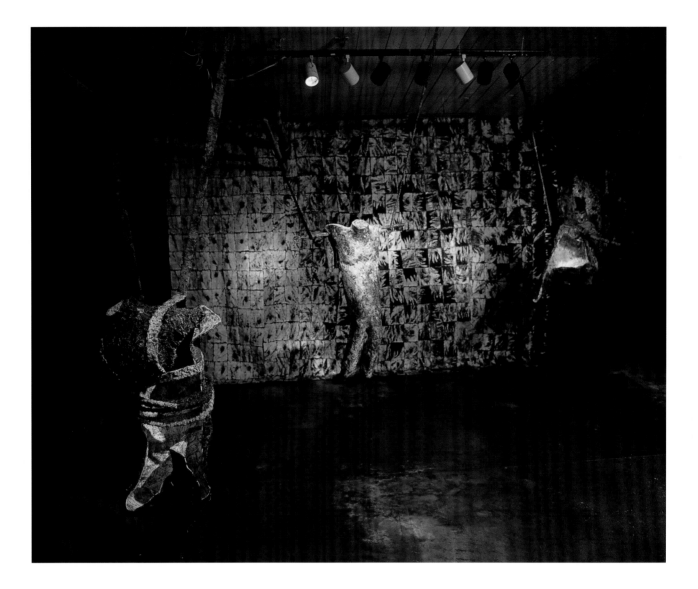

# LYDIA CSATO GASMAN

CHARLOTTESVILLE, VIRGINIA

## Opening Closed Books

2000
Mixed media
Les Yeux du Monde @ Starr Hill, 705 West Main Street

In my installation *Opening Closed Books,* I propose that a main structuring factor in Jefferson's thoughts and activities was his *par excellence* Enlightenment belief that knowledge alone makes possible political progress. Traditional and contemporary learning determined the political steps he undertook for the sake of creating a new republic. Jefferson believed that in order to create a new and better world one has to learn from and use the wisdom of the past, registered in the great books written since classical antiquity, along with their transformations consigned in the most recent philosophical, scientific and ethical studies.

*Opening Closed Books* is composed of three sections:

1. On the right-hand wall of the gallery, "The Community of Reading," a modernist and postmodern collage of letters, words, and phrases culled from Jefferson's writings and from some of his sources, together with photographs of volumes from Jefferson's spellbinding library, tell about his deep commitment to the wisdom of the past and modern discoveries. Among other things, the collaged wall indicates the classification of his libraries in terms of the three faculties of the mind—Memory, Reason, and Imagination—and his faith in a Creator who built a law-governed universe, accessible to the rational faculties of the mind. As Jefferson stated in an important letter to John Adams: "When we take a view of the Universe, in its parts general or particular, it is impossible for the human mind not to perceive and feel a conviction of design, consummate skill, and indefinite power in every atom of its composition." Also on the collaged wall are Jefferson's references to the creative power of the Logos, which he consistently translated as "reason," and to his conclusion that the morality espoused by Jesus was the most generous and the one that best befitted the norms of equality and fraternity guiding the new American nation. Facing the collage wall, life-sized standing mirrors reflect Jefferson's texts and those of his mentors. In turn the gallery's guests read the reading of the mirrors, and at the same time see themselves projected amidst those readings of readings. Reading and writing, it should become evident, both mirror and creatively transform linguis-

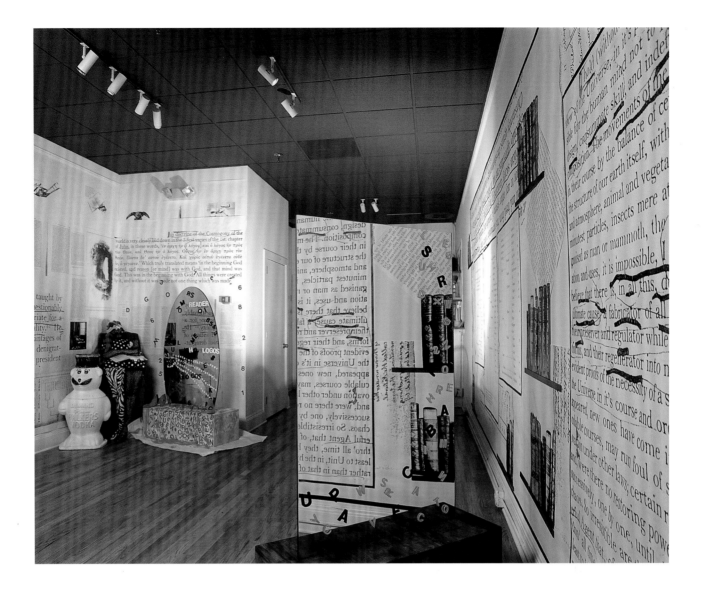

tic givens that cannot be isolated from phenomenological realities. The mirrors read as Jefferson did, and the visitors to the installation read the mirrors' readings indissociable from their own presence, thus continuing the process of creative intertexuality and its prolongation into our world.

2. The painted mural on the left-hand side of the gallery, "The Unity of the Universe," visually illustrates Jefferson's cosmology. Recalling Delaunay's orphic visions of cosmic sphericity, it represents a vitalistic, unbridled cascade of orbs and circles enacting the mythical dance of heavenly bodies. At its center, a Blakean demiurge, white hair blowing in interstellar winds, posted on an orb of silver and gold, wields his mathematical golden compass to construct the world we inhabit. He represents the rational and divine architect that Jefferson believed brought into being the empirical universe. Flanking the central architect are quotes from Edward Young and James Milton, two of Jefferson's favorite poets, and most importantly,

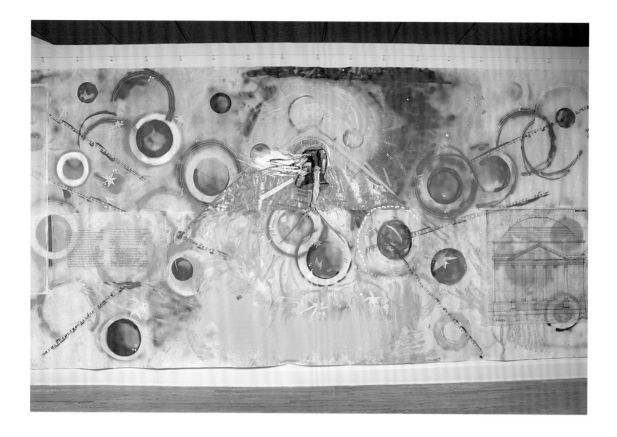

Jefferson's blueprint of the Rotunda along with his text prescribing its use as a planetarium (complete with sky-blue ceiling, stars, and an "operator" moving the stars) to explicate the operation of the great universal machine.

3. In a corner of the gallery, a mannequin entitled "The Perplexed Artist" is a self-portrait. It ironically suggests bewilderment in my search for the fundamentals of Jefferson's labyrinthine legacy, while the Styrofoam dunce bear next to me asks, "What is this all about?"

# PETER O'SHEA & ROBERT WINSTEAD

CHARLOTTESVILLE, VIRGINIA

## Blackboard: A Monument to Free Expression

1998–PRESENT

For The Thomas Jefferson Center for the
Protection of Free Expression

Proposed as a black slate wall, 65 ft. long x 8 ft. high, with
stainless steel chalk tray

To be located across from City Hall

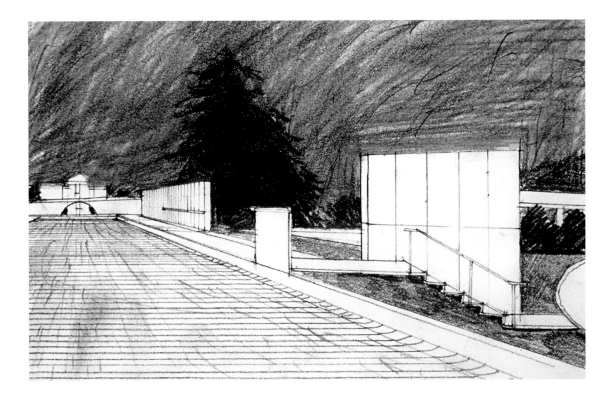

*This project has been approved by City Council and is currently in fund-raising and project development.*

The temporary installation consisted of painted Masonite panels, hand-rubbed with chalk, used to clad the interior walls of the gallery at the Thomas Jefferson Center for the Protection of Free Expression for a period of three months. Chalk was provided and the surface of the walls was not erased during this time. These panels have been preserved and recorded.

Congress shall make no law respecting an establishment of religion, or prohibiting the free exercise thereof; or abridging the freedom of speech, or of the press; or the right of the people peaceably to assemble, and to petition the Government for a redress of grievances.                              —The First Amendment of the United States Constitution

Constructed symbolism has long been recognized as a catalyst for cultural memory, collective mourning, and celebration and civic pride. Purposeful memorials are joined by ad hoc cultural monuments and serve as places of community expression, dialogue, and catharsis. We need these places. During times of despair and joy they bring us together. They are the backdrops of our civic struggles. These are the places we gather when our foundations have been shaken or when we feel the need to express our views. We need these places to help us reaffirm our beliefs and politics—our foundations—our community. A fundamental element of our democratic society is the protection afforded by the First Amendment to express ourselves freely. To gather when we feel the need, to disagree, to shout out loud and to join quietly together. We can express our beliefs without fear of government retribution or censorship. We can challenge each other through dialogue. We can ask our officials to listen. This founding freedom protects all manners of expression: word, image, voice, song, dance.

This project proposes to bring tangible and daily embodiment of this freedom to the community of Charlottesville, Virginia, the home of Thomas Jefferson and James Madison, who authored the First Amendment. This monument will be an interactive and dynamic construction of civic life and thought. It will require that we exercise the right of free expression as a core responsibility of being citizens. It will serve as a catalyst for debate and dialogue and as a place to express joy and sorrow. It will mark and measure the emotions and politics of our community. Love, hatred, ignorance, brilliance, stupidity, skepticism and hope will occupy the surface of this wall. We will write and draw and wipe away all of these. And then we will start over again and again. This will be a place where we struggle publicly with the way things are and make proposals for the way we think things should be.

A temporal record of community thought, a space for making and proclaiming, this surface will register the tide of public opinion and desire. It will be both a registration of and a backdrop for the spontaneous performance of civic life. Air your grief. Express your hope. Voice your beliefs. Ask for help. Words and images and scratches and wiped-away messages will exist as a dynamic palimpsest of our place and time. This freedom requires exercise. Interaction is required.

# LINCOLN PERRY

YORK, MAINE

## A Student's Progress

2000
Eleven-panel mural; oil on canvas on wall, roughly
12.5 ft. x 72 ft.
Old Cabell Hall, University of Virginia

*Made possible with the support of W. L. Lyons Brown, Jr., Cary Brown-Epstein, W. L. Lyons Brown, Jr. Charitable Foundation of Louisville, and members of the Mural Project Advisory Committee.*

I find Mr. Jefferson an extremely complex man, working behind the scenes to be president while appearing to be above politics, running as the anti-monarchist man of the people while living beyond his means as an aristocrat supported entirely by slave labor. But his accomplish-

ments are manifest, especially at his University, which might have served as a model for all subsequent thinking in this country about architecture and community. I find it perhaps our greatest group of communal buildings and deeply regret that some of its lessons were not explored further in the years since its completion. In sympathy with its use of metaphoric spatial development, I wanted to demonstrate that Mr. Jefferson's thinking is in no way outdated and is perhaps more needed now than ever. Despite or perhaps because of the contradictions of his life, he thought carefully about how to form young minds in a young country, and I can only hope that he would understand some of the decisions I made in painting this cycle of narrative murals. Depicting the progress of a young and awkward student through four years from the first day of class to graduation, these eleven panels are meant to find the kind of passage from culture to nature I believe Mr. Jefferson had in mind when he made the Rotunda face and guide the student out and into the mountains beyond. Education implies individuation; here, despite setbacks, the young redhead enters virtual space, finds herself in the crowd, works at her instrument and eventually gets to both play for her own satisfaction and launch herself with group support out into the space of the world. The narrative of the taken for granted, the subtly quotidian, the repeating pattern, interests me more than the self-consciously novel, the easily ironic, or the desire to épater one's own bourgeoisie. Mr. Jefferson's Academical Village set an example as viable now as in 1826; that is the kind of art I admire, one that never ages but that becomes richer over time.

# THOMAS JEFFERSON

## AND THE LAND: THE VIEW FROM MONTICELLO

### Lucia Stanton

"NATURE SO CONTRIVED IT," THE MARQUIS DE CHASTELLUX WROTE AFTER A VISIT TO Monticello in 1782, "that a Sage and a man of taste should find on his own estate the spot where he might best study and enjoy Her."[1] More than a century later, a Baptist minister remembered the Virginia plantation where he had been born into slavery and the telescope on Monticello's north terrace where Thomas Jefferson and James Madison "spent a great deal of their time." Peter Fossett, setting the stage for a story about the arrival of British troops at Monticello during the Revolution, recalled how "one day . . . Mr. Jefferson was looking through his telescope to see how the work was progressing over at Pan Top, one of his plantations."[2]

Several other stories told by former slaves or their descendants portray Jefferson with spyglass in hand, elevated above the surrounding landscape and its inhabitants, inspecting his immediate world. These accounts amplify those of learned travelers like Chastellux, who famously noted that Jefferson had "placed his mind, like his house, on a lofty height, whence he might contemplate the whole universe."[3] They capture him as monitor and manager as well as philosopher, surveying both the universal and the particular from his mountaintop.

From his perch, five hundred feet above the river that bisected his five-thousand-acre property, Jefferson could oversee his laborers, measure his surroundings, and contemplate "truth and nature, matter and motion." Peter Fossett's reference to Pantops is strikingly apt, given the double meaning of the Greek name Jefferson gave it: all-seeing and seen by all. To his unlimited prospect Jefferson brought countless ways of seeing, and he had daily access to sublimity, a favorite object of most eighteenth-century men of letters: "How sublime to look down into the workhouse of nature, to see her clouds, hail, snow, rain, thunder, all fabricated at our feet! and the glorious sun when rising as if out of a distant water, just gilding the tops of the mountains, and giving life to all nature!"[4]

The mountain that became Jefferson's fixed viewpoint had been his "favorite retreat" as a

schoolboy. He took his books to its highest point, where "he never wearied of gazing on the sublime and beautiful scenery that spread around, bounded only by the horizon, or the far off mountains."[5] Books were embedded in Jefferson's response to his environment and the authors of ancient Rome made an indelible first impression. In the paeans to country life of Horace and Virgil he encountered an ideal world that he sought to recreate and inhabit, in the face of the harsh realities of the climate and culture of his region. At Monticello, as at the villas of the Romans, he would blend rural delights with the urban refinements of literature and science. In the *Georgics,* in particular, as Douglas L. Wilson has demonstrated, lay "the essence of Jefferson's agrarianism." Jefferson found both personal and national ideals in Virgil's poem in praise of agriculture, and his idealized American farmer—industrious, virtuous, and independent—was an eighteenth-century incarnation of Virgil's *agricola.*[6]

Rome, and the universal standards of beauty expressed in its buildings, inspired Jefferson's first act in a lifetime spent modifying the surface of the earth. In the summer of 1768 he had the top of his mountain lopped off to form a level for his own adaptation of many of the elements of the Roman villa. His first plans placed the neoclassical dwelling at the center of a series of geometric terraces, the outermost one in the shape of a Roman racecourse, or "circus." In the end he scaled down his ambitions, and the strict geometry of the "circus" took the more natural form of the First Roundabout. Perpetual road building and construction of a vegetable garden terrace nevertheless required further episodes of monumental earth-moving. While the sheep pastures and wheat fields on Monticello's slopes have grown up into woodland, Jefferson's efforts to recreate a rural ideal are still visible under the tulip poplars and Virginia pines. Near the mountain's springs are the ghostly outlines of the North Road, overgrown with trees; heaps of stone testify to the use of gunpowder as well as human labor to carve this entrance road out of the rocky north-facing incline above the river. On the softer southern exposure, there are gullies broad enough to launch an ocean liner, inadvertent reminders of a bold agricultural experiment.

"You know how much I have at heart the preservation of my lands in general," Jefferson wrote to his steward in 1791. He had observed the need to counteract "the progressive degradation of our lands" resulting from the slovenly practices of most Virginian farmers.[7] As an efficiency-minded child of the Enlightenment, he deplored the waste of resources in a state where land was so plentiful and cheap that, when soil was exhausted by successive crops, farmers merely opened up new ground or moved farther west. Jefferson, who believed that "small landholders are the most precious part of a state," embarked on a reforming crusade against the forces of soil exhaustion and emigration. Its central feature was his own agricultural revolution at Monticello, which he hoped might set an example.[8]

On his retirement from public life in 1794, Jefferson began to rebuild a soil depleted by decades of the ruinous rotation of corn and tobacco. These crops were banished from his new seven-year rotation schedule, which substituted wheat as the staple crop and introduced three years of red clover, a soil-improving legume. He spent weeks with his theodolite, and a cohort

of chain carriers, surveying Monticello's fields and revising their boundaries to make twenty-eight plots of forty acres each. A mixed grain and livestock operation replaced the single-minded quest for a tobacco crop, and suddenly plows were in the fields every working day of the year. Vastly increased erosion was the ironic consequence of these reforms. "I imagine we never lost more soil than this summer," Jefferson wrote in 1795 after "such rains as never came I believe since Noah's flood."[9]

The same letter reveals the first hints of a reformer's disillusion: "It will be the work of years before the eye will find any satisfaction in my fields." Discouraged as well by the difficulty of achieving productivity without cruelty, Jefferson wrote a few years later, "I am not fit to be a farmer with the kind of labour that we have."[10] His systematic restoration efforts had to be postponed for presidential duties, but by 1807 his view was transformed by a new practice that satisfied both his scientific and aesthetic appetites. He credited his son-in-law Thomas Mann Randolph with introducing "horizontal" or contour plowing to Albemarle County. One January day Jefferson observed a fourteen-year-old slave laying down the guidelines for the plowman with a rafter level: "Thruston makes a step of the level (10 f.) every minute, which is 600. f. = 200. yds an hour." In 1813 he described the effects of Thruston Hern's guidelines and the plowman's furrows: "In point of beauty nothing can exceed that of the waving lines and rows winding along the face of the hills and vallies."[11] Here was something rare outside of the garden, an aspect of agriculture that accorded with Jefferson's love of the combination of beauty and utility, the *utile dulci* (the useful with the delightful) of his favorite Roman poet, Horace.

Jefferson's stewardship of the land extended beyond Monticello. In his *Notes on the State of Virginia* he set up southern rivals to the famous natural wonders of the north. Without ever having seen Niagara Falls, he declared the Natural Bridge to be "the most sublime of nature's works."[12] His rhapsodic description of the passage of the Susquehanna through the Blue Ridge at Harper's Ferry created a host of disappointed travelers in succeeding decades. Jefferson, who was serious about assuring the preservation of these remarkable features of the Virginia land-scape, set up his own private land conservancy as early as the 1770s. He tried to patent the land on which the subterranean cavern known as Madison's Cave was located and he succeeded in buying the Natural Bridge. When leasing it as a shot tower during the War of 1812, he enjoined the tenant to do nothing to disfigure the bridge, "as a natural curiosity," and three years later, he viewed the land "in some degree as a public trust."[13]

When, in 1794, Jefferson made the wheat fields along the bony spine of Monticello equal in size, he also made them square. His visual imagination was haunted by geometry, the foundation of the Newtonian laws of physics that governed Monticello as well as the solar system. Jefferson's architectural and landscape designs are embellished with ellipses and octagons, and the grids of the Monticello fields were a reflection of his ideas for the entire American continent. In the Land Ordinance of 1785 Jefferson's concept of dividing new lands into rectilinear units aligned with the points of the compass became the basis of the federal survey system. He

thus transferred onto the lands of the west, in disregard of all topography, a geometric landscape of the mind.

In his engagement with his view, which encompassed both his own land and the more distant prospects of his county, country, and continent, Jefferson was armed with an array of observing tools. As heir to his father's mapping mentality and an enthusiastic disciple of Sir Francis Bacon, he had outfitted himself for a lifetime of systematic inquiry. While his favorite Ramsden theodolite was equal to most angle measurement, he could also draw from a very fine collection of "mathematical apparatus" with magnifying and orienting properties. For observation of the annular eclipse of the sun in 1811, Jefferson brought out the most sophisticated astronomical instrument in the nation, his Ramsden universal equatorial telescope. Jeffersonian astronomy did not involve a review of the heavens in search of comets and planets, in the manner of Halley and Herschel. He used the heavenly bodies to learn about his particular spot on earth. As he wrote in 1816, "we cannot know the relative position of two places on the earth, but by interrogating the sun, moon, and stars."[14] And he repeatedly questioned the heavens to fix his own position in the universe and to contribute to a "true geography" of his country, one of his national goals. Jefferson's own role in measuring America included calculating the elevations of Virginia mountains and the latitudes of local landmarks. Finding Monticello's longitude had been the point of observing the 1811 eclipse. At the age of seventy-two, he ascended to the top of one of the Peaks of Otter to take measurements "to gratify a common curiosity as to the height of those mountains, which we deem our highest."[15]

If the measurements of a lifetime could be made visible, Monticello would be enveloped in a web of sight lines connecting the columns of the house, barns and cabins on the plantation, chimneys in the neighborhood, local mountains, and "the sun, moon, and stars." The constantly triangulating Jefferson, fortified by his optical tools and his logarithmic tables, was doing more than distancing himself from the world with a mist of mathematics. Measuring, as well as managing, the landscape was not simply a method of control. These actions were associated with his deep commitment to the Enlightenment ideal of putting knowledge to use for the public benefit. For a passionate Baconian like Jefferson, the belief that the systematic collection of facts was the path to knowledge invested every measurement or calculation, no matter how minute, with the satisfaction of larger purpose. While he sent others to venture off the edge of maps, he stayed at home launching his own local expeditions to clover fields and hilltops.

Jefferson viewed his agricultural activities as dedicated to the welfare of his fellow Americans. When he imported a model of the recently patented Scottish threshing machine or sampled various spinning machines during the War of 1812, he wanted to "save the labours of my countrymen."[16] He believed his farming renewal efforts of the 1790s might be "of some utility to my neighbors, by taking on myself the risk of a first experiment of that sort of reformation in our system of farming."[17] At the same time, Jefferson must have been aware that his neighbors looked askance at his method of farming by the book. And Peter Fossett, who

in 1827, at the age of eleven, was sold away from Monticello and his family, was excluded from Jefferson's most famous expression of an agricultural ideal. When he wrote that "those who labour in the earth are the chosen people of God," Jefferson was not thinking of his own laborers.[18]

At the height of his agricultural revolution in the 1790s, Jefferson revealed his remarkable capacity to sustain a harmonious ideal vision in the midst of discordant realities. The entanglements of slavery and the frustrations of farming were forgotten in an enthusiasm that derived from what he called his "zeal for improving the condition of human life." In a letter to Maria Cosway he described himself as "retired to my home, in the full enjoyment of my farm, my family, and my books." After sketching out the route of a trip to Italy he wished to take in her company, he wrote: "We will leave the rest of the journey to imagination, and return to what is real.—I am become, for instance, a real farmer, measuring fields, following my ploughs, helping the haymakers, and never knowing a day which has not done something for futurity."[19]

## NOTES

1. Merrill D. Peterson, *Visitors to Monticello* (Charlottesville: University Press of Virginia, 1989), 11.
2. *New York World*, 30 January 1898.
3. Peterson, *Visitors*, 13.
4. TJ to Maria Cosway, 12 October 1786, *The Papers of Thomas Jefferson*, ed. Julian P. Boyd et al. (Princeton: Princeton University Press, 1950), 10:447, 449.
5. Gaillard Hunt, ed., *The First Forty Years of Washington Society* (New York: Charles Scribner's Sons, 1906), 387.
6. Douglas L. Wilson, "The American *Agricola:* Jefferson's Agrarianism and the Classical Tradition," *South Atlantic Quarterly* 80 (summer 1981): 349.
7. TJ to Nicholas Lewis, 4 April 1791, *Papers*, 20:103; TJ to Ferdinando Fairfax, 25 April 1794, *Papers*, 28:58.
8. TJ to James Madison, 28 October 1785, *Papers*, 8:682.
9. TJ to Thomas Mann Randolph, 18 August 1795, *Papers*, 28:438; TJ to George Washington, 12 September 1795, *Papers*, 28:465.
10. TJ to Stevens T. Mason, 27 October 1799, *Thomas Jefferson's Garden Book*, ed. Edwin Morris Betts (Philadelphia: American Philosophical Society, 1944), 267.
11. Edwin Morris Betts, ed., *Thomas Jefferson's Farm Book* (Princeton: Princeton University Press, 1953), facsimile p. 123; TJ to Charles Wilson Peale, 17 April 1813, *Garden Book*, 509.
12. Thomas Jefferson, *Notes on the State of Virginia*, ed. William Peden (Chapel Hill: University of North Carolina Press, 1955), 24.
13. Agreement with Philip Thornton, 2 December 1814, Massachusetts Historical Society; TJ to William Caruthers, 15 Mar. 1815, Library of Congress.
14. TJ to Wilson Cary Nicholas, 19 April 1816, *The Writings of Thomas Jefferson*, ed. Andrew A. Lipscomb and Albert Ellery Bergh (Washington, D.C., 1904), 14:484.
15. TJ to Alden Partridge, 2 January 1816, ibid., 377.
16. TJ to James Adair, 1 September 1793, *Papers*, 27:4; TJ to Robert Livingston, 20 April 1812, *Farm Book*, 474.
17. TJ to Ferdinando Fairfax, 25 April 1794, *Papers*, 28:58.
18. Jefferson, *Notes on the State of Virginia*, 164.
19. TJ to Maria Cosway, 8 September 1795, *Papers*, 28:455.

# DOVE BRADSHAW

NEW YORK, NEW YORK

## Notation II

2000
Alberene soapstone, copper, 27 in. x 45 in. x 34 in.
Collection: Beatrix Ost and Ludwig Kuttner
Estouteville Farm, Keene

The involvement with indeterminacy began in 1969. Over the past thirty-three years various metamorphic processes have been set in motion by combining unstable and stable materials. Their interaction takes precedence over issues of taste in regard to color, structure, or composition. Some of the gestures toward indeterminacy have embraced the unpredictability of birds, the gradual erosion of water, the instability of various materials, including acetone, mercury, and sulfur, as well as materials particularly susceptible to weather and indoor atmosphere. Time is no less significant a factor than the materials themselves.

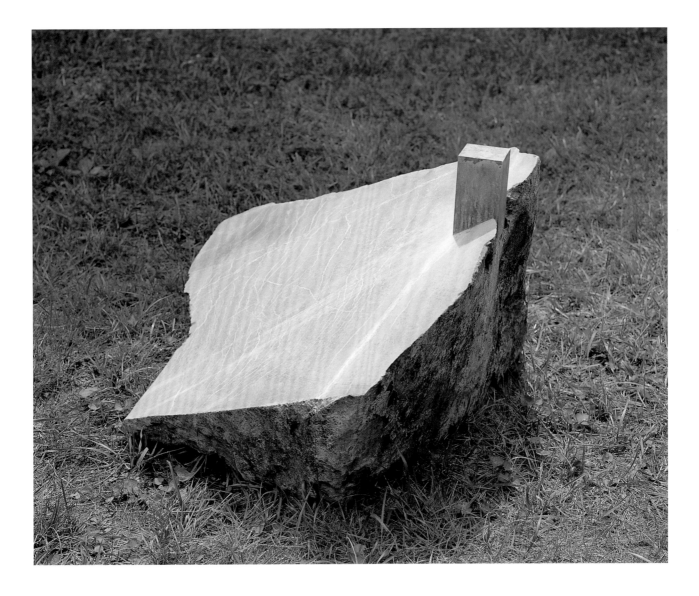

# SUSAN CROWDER

CHARLOTTESVILLE, VIRGINIA

## Angus

2000
Three large round hay bales (72 in. diameter x 68 in. long)
partially covered with tar and asphalt and placed randomly
in the space to suggest cattle grazing; roofing paper, mixture
of roofing tar and asphalt gravel
Edgehill Farm

Thomas Jefferson was passionately interested in both architecture and farming. His house and farm were sited above the city of Charlottesville so that he could look down and see the progress of the development of the University and the city.

Jefferson understood the need for a harmonious balance in the landscape between fields and pastures and buildings and roads. *Angus* explores the idea of the tension between the traditional farming way of life in Virginia and the dynamic growth that threatens the pastoral use of land around Jefferson's beloved Charlottesville.

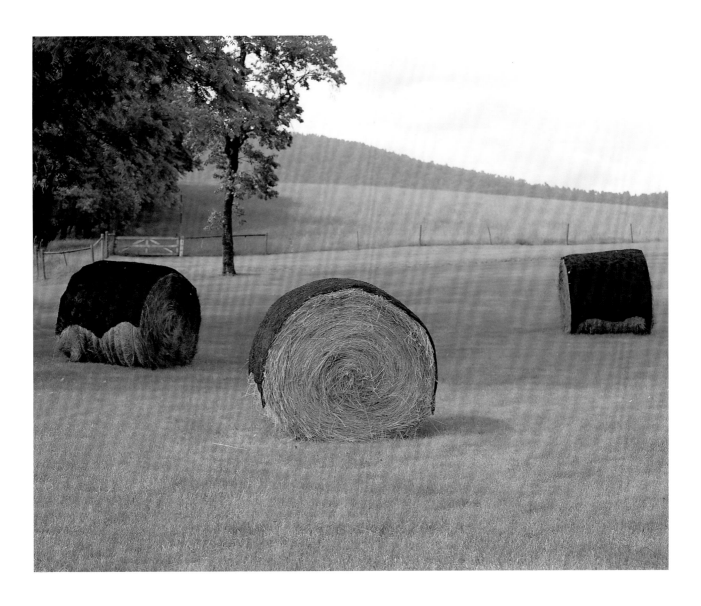

# DAN MAHON, artist coordinator

CHARLOTTESVILLE AND AMHERST COUNTY

## Stomping Grounds: Myth Fixing and Place Making

Stone dust, native clay, plastic toy figures
Darden Towe Memorial Park, VA Route 20, about 1 mile
north of US Route 250

*with the Monacan Indian Community
and the Living Earth Design Group*

As an artist, community facilitator, and placemaker with The Living Earth Design Group, I was involved for my work on *Stomping Grounds* in a great deal of planning with county officials and members of the Monacan community, including the chiefs and tribal council. Klynn and Danny "Red Elk" Gear provided special support, and they, along with the tribal dancers and drummers, woke up the spirit in the ground. *Stomping Grounds* was conceived as an initial step in providing a foundation for a new mound for a contemporary Monacan Nation that is envisioned to be built with layers of earth leveled with song and dance, remembering time past; the construction would occur over time.

The ground for this piece sits high on a bluff overlooking the Rivanna River. A path or labyrinth representing the river wound along the top of the bluff and connected with a low circular mound of red clay representing the village of the people once located there. The river sustained these people. Four posts holding offerings of thanks were placed in four directions

around the mound. Inside the circle were numerous painted plastic toy Indian figures, made in China. These figures represented the myth of the "savage" Indian as well as the market in fake Indian art and exploited spirituality. Just like Indian stereotypes, these plastic Indian figures were not real. Modern members of the tribe gathered, sang, and drummed at the site. The exhibition concluded with a ceremonial stomping of the figures into the ground. The art-of-fact left remaining in the circle was simply the footprints of the modern Monacan Indians.

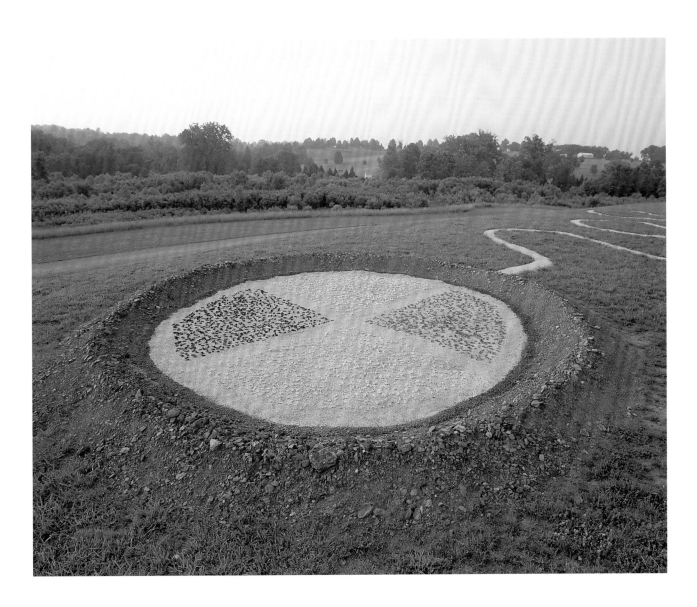

# MEGAN MARLATT

ORANGE, VIRGINIA

## How the Mind Travels

Drawings and mixed media
Windows, corner of the Downtown Mall and
First Street South

For this exhibition a series of large, layered drawings was created for a public embankment of seven shallow windows. The drawings were based on a list written by Meriwether Lewis on April 3, 1805, providing an inventory of seven crates of specimens returned to President Thomas Jefferson from a Mandan village in what is now North Dakota. I was moved by the vision of these crates floating down the Missouri River, traveling from one powerful person (Meriwether Lewis) to another (Thomas Jefferson). I made artistic use of that image of this historic episode as a metaphor for how the mind travels. In using this metaphor, I attempted not only to record visually the history that had passed, but also to explore the contents of two brilliant minds, one cautious and hopeful (Jefferson), the other tormented and dark (Lewis).

## How the Mind Travels

Asphaltum on asphalt, hundreds of birds, each
approximately 6 in. in length
Estouteville Farm

This work involved paintings on pavement of the shadows of birds flying south in migration. The birds represent how the mind travels, the freedom of thought patterns, and the pursuit of great ideas.

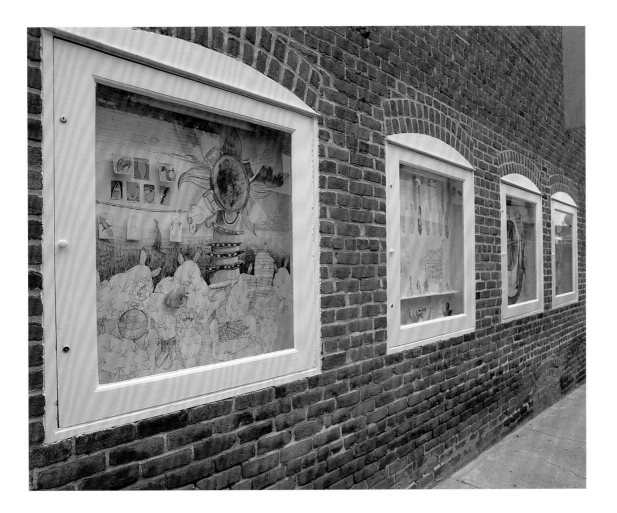

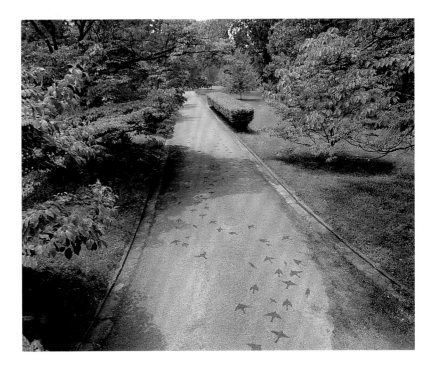

# BEATRIX OST

KEENE, VIRGINIA

## Table of Plenty

2000
Maze, table, glass and steel beehive, bees, netting
Estouteville Farm

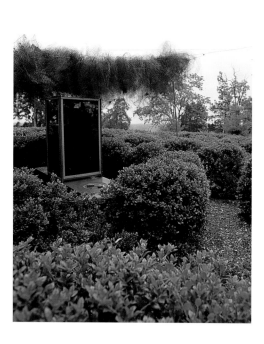

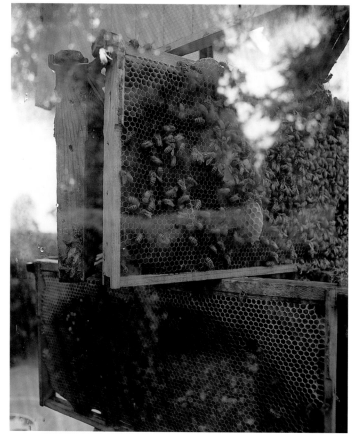

The tableau for the bees rests beneath the ominous cloud inside the labyrinth that puzzles us at all levels of existence. The bee is genetically driven to resolve its own chaos by constructing what for us is yet another mysterious labyrinth. The honeycomb is a living mandala, another signpost in Jorge Luis Borges's "Garden of Forking Paths."

46

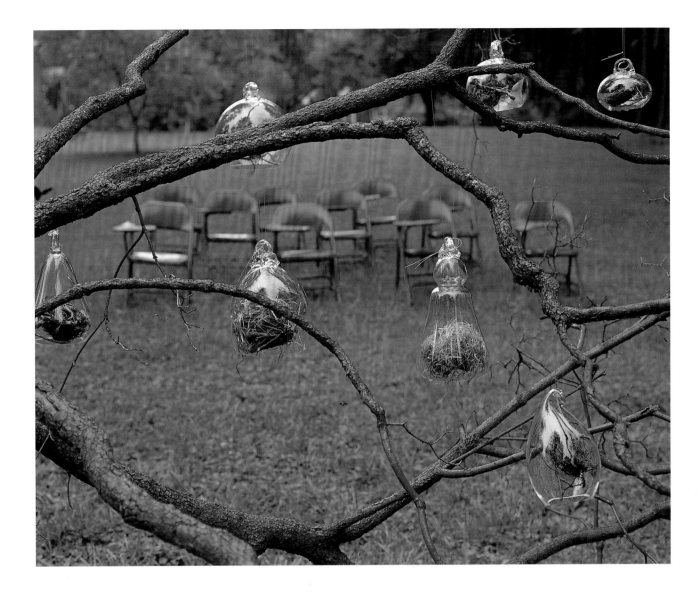

## Nature Morte

2000
Dead tree, paint, classroom chairs
Estouteville Farm

The artificial tree must fall. We attempt to encapsulate the essence of the egg. Will we be gods, seeding new planets and new species? Or will we be left with only a laboratory of crutches?

# LUCIO POZZI

NEW YORK, NEW YORK

## The Charlottesville Color Game

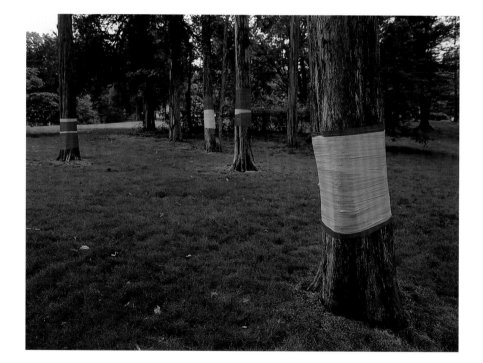

The city and its people are the work of art. Instead of adding a monument to the urban fabric, my art consists of markers that punctuate the city by adding touches of color and shape to it. The objects I use to mark selected places in Charlottesville are representative not only of their own specificity but also of facets of modern American life such as movement, childhood, nature, words. These were foreshadowed by Thomas Jefferson's contribution to the understanding of existence in this culture. Blue, red, green, and yellow are the four colors used to distinguish the markers that are scattered in Charlottesville. I have used these colors in one way or another many times before. The markers—"The Children's Fill," "Parking," "A Color Game

on Nature," "Reading the Paper"—emerge from a full collaborative partnership with artists and organizers who live and work in Charlottesville and who were intentionally given vague directives so that their contributions in ideas and draftsmanship would affect the final result.

## The Children's Fill

Virginia Discovery Museum, 524 Main Street East
Fenella Belle, Coordinator
Styrofoam, paint

Respect for the magic of childhood and the importance of play are sources from which a creative individual and an alert collectivity draw much power. A transparent Plexiglas wall is erected a few feet away from the back wall of a child's playroom. When young visitors come they are asked to paint chunks of Styrofoam, each piece in one of the four colors—blue, red, green and yellow. The gap fills and becomes a three-dimensional impromptu mosaic.

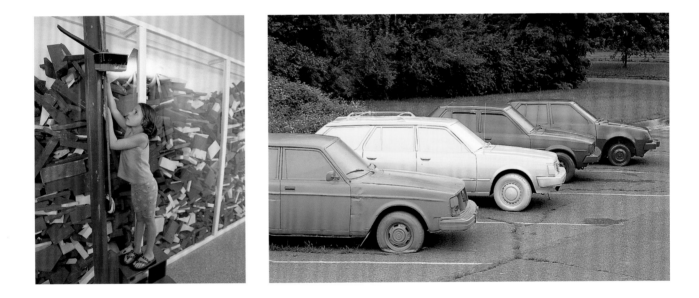

## Parking

Four cars, painted
Frank Ix Building, 531 Ware Street, outside

The automobile is the epitome of our society's mobility. It portrays the positive and negative connotations of our world. Freedom of individual choice and dependence on market publicity, security and danger are what cars symbolize and represent in fact. We have parked four

cars side by side in a lot. Each is completely painted, including windshields and tires, with shiny weatherproof enamel in one of the four colors. The cars become like giant toys fixed in the space.

## A Color Game on Nature

Saint Anne's–Belfield School
Surveyor's flags, surveyor's tape, ceramic cylinders

Meg Chevalier, Randi Bill, and Kim Cox created this piece with the help of their students. A giant double spiral, based on the telescopic photograph of a spiral-armed galaxy, was made by planting innumerable yellow, blue, red, and green surveyor flags on the immense field alongside the hill in front of St. Anne's–Belfield. Ceramic "tree sleeves" in the same four colors were placed on trees around the campus. Mushroom-shaped ceramics were added like growths onto tree stumps. Other trees were wrapped in surveyor's tape in different color combinations and patterns. The visitor could engage in a kind of treasure hunt seeking the various visual events marking the garden.

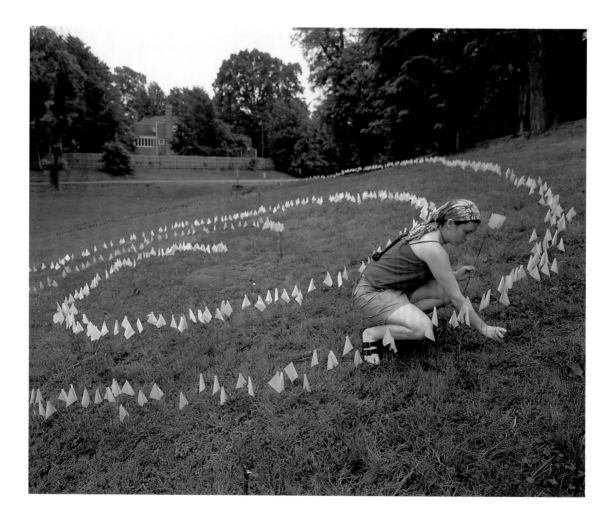

## Reading the Papers

Performance Piece, June 17, 2000, 9 A.M.–5 P.M.
Paramount Theater, 300 East Main Street

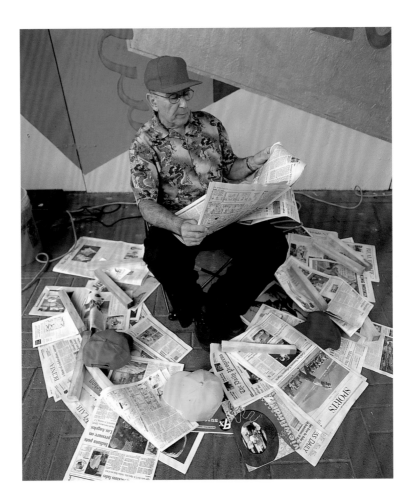

I like to present eight-hour-long performances, in sympathy with the general 9-to-5 working routine of most people in this country. By performing for eight uninterrupted hours, I also add an endurance wager to this family of my artworks. Spoken and written words and the information they convey are among the prime factors of our civic experience. The artworks in the *Charlottesville Color Game* all have different durabilities incorporated in their program. The performance "Reading the Papers" is the most ephemeral of the group. I sit on a chair. Strewn on the floor around me are local papers of that day and week. I pick them up one at a time and read at random fragments of news, announcements, obituaries, or marriage notes. I always change the names of the persons mentioned in the text to one of only two other names: John Smith for men and Mary Jones for women. Every couple of minutes or so I also pick up from the floor one of the hats I have placed there, each in one of the four colors, and exchange it for the one I am wearing.

# JAMES WELTY

CHARLOTTESVILLE, VIRGINIA

## A Short History of Decay

2000
Welded copper
Estouteville Farm

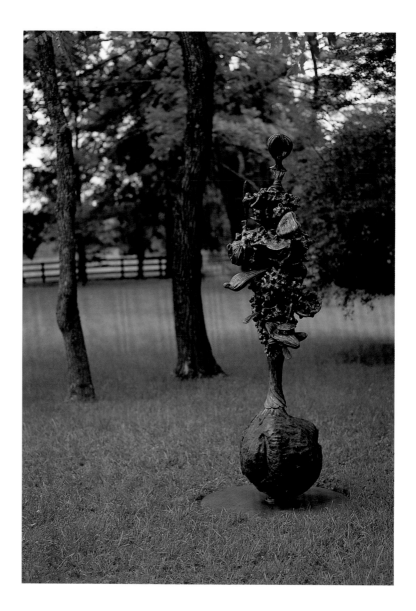

# THOMAS JEFFERSON

## RACE AND NATIONAL IDENTITY

Peter S. Onuf

GETTING TO KNOW JEFFERSON BETTER CAN BE A DEMORALIZING EXPERIENCE. FOR MANY Americans today, a first exposure to his commentary on race in Query XIV of the *Notes on the State of Virginia* is sufficient to subvert his iconic standing in the pantheon of founding fathers. Jefferson "suspected" that people of African ancestry were "inferior" to Europeans in their mental capacities and therefore not fit for citizenship in the new revolutionary republics. The racial boundary he charted in his *Notes* between whites and blacks—a line that denied kinship ties and divided many Virginia families, including his own—strikes us now as arbitrary, unnatural, and undemocratic. Jefferson apparently did not recognize, and he certainly did very little to resolve, the contradiction between the American struggle for independence and the continuing enslavement of approximately one-fifth of the total American population. Our recognition of this contradiction has tarnished—and for his bitterest critics, demolished—Jefferson's reputation as the "father of democracy."

Over the last half century, many Americans have come to believe that our nation's democratic promise will not be realized until we have overcome the legacies of slavery, segregation, and racism. Jefferson embodies this "American Dilemma." The ringing phrase of his Declaration of Independence—"all men are created equal"—constitutes our national creed, a promissory note that we have not yet fully honored. Jefferson defaulted on his own promise as the visionary professions of the democratic philosopher gave way to the prudent calculations of the slave-owning planter. When we learn that he freed only a handful of the many hundreds of enslaved African Americans he owned, and that those few—including his children with Sally Hemings—had strong personal claims on his solicitude, we begin to suspect that Jefferson himself is the problem. The discrepancy between practice and profession is a classic case of what the philosophers call "bad faith." And if Jefferson did not mean what he said, if those ringing phrases ring hollow, where does that leave us as a people?

We define democracy as inclusion. Jefferson defined slaves as aliens with no claim to membership in the new American nation. If his Declaration calls on a free people to burst the chains of despotism, his *Notes* tells black people that they will have to pursue their happiness elsewhere, anywhere but here. African American students at Mr. Jefferson's University who read his words can feel like uninvited guests, or worse. In a seminar discussion, one young woman described suddenly feeling that she "did not belong here," that Jefferson was telling her that there was no place for her in his "academical village."

She had read that black was anything but beautiful. "The first difference which strikes us is that of colour," Jefferson explained. Whatever the source of that difference, it was clearly "fixed in nature," and was "the foundation of a greater or less share of beauty in the two races." Whites could express their finer feelings by "suffusions of colour," by "the fine mixtures of red and white" in a blushing countenance, while an "immovable veil of black . . . covers all the emotions of the other race." Jefferson's color line was keyed to sexual attractiveness. Black men lusted after white women, just as the male orangutan favored "black women over those of his own species." There was a deeper, racial logic to sexual preferences that more squeamish observers might blush to acknowledge: "the circumstance of superior beauty, is thought worthy attention in the propagation of our horses, dogs, and other domestic animals; why not in that of man?"

Jefferson's ruminations on racial difference proceeded from the outside in, from skin color to internal organs—"they secrete less by the kidneys, and more by the glands of the skin, which gives them a very strong and disagreeable odour"—to emotional dispositions and mental capacities. Black men were "more ardent after their female," he observed, "but love seems with them to be more an eager desire, than a tender delicate mixture of sentiment and sensation." Once their appetites were satiated, they subsided into unfeeling lassitude: "their griefs are transient." This insensibility was directly linked to mental inferiority. Though "in memory they are equal to the whites," Jefferson acknowledged, blacks were "in reason much inferior, as I think one could scarcely be found capable of tracing and comprehending the investigations of Euclid," and "in imagination they are dull, tasteless, and anomalous; . . . never yet could I find that a black had uttered a thought above the level of plain narration; never see even an elementary trait of painting or sculpture." Among whites suffering produced great art; "among the blacks is misery enough, God knows, but no poetry."

In conclusion, Jefferson "advance[d] it therefore as a suspicion only, that the blacks, whether originally a distinct race, or made distinct by time and circumstances, are inferior to the whites in the endowments both of body and mind." His defenders seize on the "suspicion," emphasizing the scientific stance of the natural philosopher who remained open to further evidence and argument. But the important thing about this passage is that Jefferson thought racial differences were fixed in nature, whatever their source and however they might be assessed. His comparative method focused on and therefore exaggerated racial differences. Where other observers invoked environmental conditions and cultural constraints to explain

racial distinctions, Jefferson's approach worked in the opposite direction as "time and circumstances" conspired with nature to produce a natural racial hierarchy. Philanthropy thus decreed separation. "Will not a lover of natural history then, one who views the gradations in all the races of animals with the eye of philosophy, excuse an effort to keep those in the department of man as distinct as nature has formed them?"

Jefferson's defenders cannot say that he did not say these awful things. But they insist that his "racism" should not be allowed to overshadow his fundamental commitment to human rights and his contributions to the history of freedom in the modern world. They have a point. Jefferson was certainly a great exponent of natural rights; his testimony against the injustice of slavery remains compelling, particularly in view of his "suspicions" about black inferiority. A later generation of pro-slavery ideologues would justify the institution as the most humane and civilized means of sustaining the racial order that Jefferson described in his *Notes*. But Jefferson was moving in the other direction, *from* the notion that slaves were subhuman and therefore as much "subjects of property as . . . horses and cattle" *to* the recognition of their fundamental, irreducible rights as fellow human beings. A friendly critic might even suggest that Jefferson's commentary on racial differences ultimately underscores his commitment to rights, for even if his conclusions were in fact all justified they did not justify the tyrannical rule of one race over the other. We might further argue that Jefferson's anthropology, having raised enslaved African Americans from the status of barnyard animals to that of fellow human beings, however inferior their endowments, could have evolved still further to the more robust equalitarianism that we now embrace.

But this is where wishful thinking gets the better of historical understanding. Jefferson lived long enough for his racial thinking to evolve. It didn't.

My student got the point. Jefferson's commitment to racial separation was fundamental, not provisional: it was inextricably linked to his conception of American nationhood. She recognized instantly that she had no place in Jefferson's vision of the American future. Instead, Jefferson repeatedly insisted, black slaves should be emancipated and then "colonized to such place as the circumstances of the time should render most proper, sending them out with arms, implements of houshold and of the handicraft arts, seeds, pairs of the useful domestic animals." Only then would it be possible for slaves and their descendants to exercise their natural rights, as whites who had declared their own independence from Britain would in turn "declare" their former slaves "a free and independent people, and extend to them our alliance and protection, till they shall have acquired strength" sufficient to stand on their own in the family of nations.

Of course, we don't and shouldn't think of our nation as Jefferson envisioned it. We might pause a moment, however, before consigning him to history's dustbin. What we rightly honor in Jefferson's legacy is inextricably implicated in what we would deny or discard. Is there any way to unravel the knot?

The crucial concept for Jefferson was *nation,* a long-familiar concept that was undergoing

a profound transformation in his time. A "nation" was a "people," or race or ethnic group—synonymous terms that were not then clearly distinguished. During the revolutionary era Jefferson and other Americans began to think of themselves collectively as a nation in a more specifically political or legal sense derived from the "law of nations." Their Declaration of Independence was a plea for the recognition of that nationhood by other nations in the (European) family of nations. As many readers have noted, there is a profound circularity in the Declaration's logic. Before the Declaration there was no "nation" capable of declaring its own existence, only a loosely affiliated union of disaffected British provinces seeking to renegotiate the imperial constitution. By solving—or rather, by disguising—this fundamental dilemma of new nationhood, Jefferson can be credited with "inventing America," to borrow Garry Wills's suggestive phrase. The trick was to convince Americans themselves that they *were* a people entitled by "nature and nature's god" to exercise sovereign rights. "Popular sovereignty" was synonymous with national self-determination, or liberation.

These may strike us as bloodless abstractions, mere inventions of revolutionary propagandists. But they spoke powerfully to Jefferson and his contemporaries. On one hand, blood was already being shed, and these great sacrifices needed to be justified. The revolution would only succeed if Americans could imaginatively transcend the cross-cutting provincial, ethnic, religious, class, and even linguistic differences that traditionally separated them. The concept of nationhood, the idea that Americans were all members of a great family of families, provided a sentimental rationale for suffering and sacrifice.

Why couldn't racial differences be subsumed and obliterated in the same way? Of course, in some instances they were, particularly when slaves and freed people and Indian allies were mobilized in the revolutionary war effort. Jefferson himself could occasionally imagine absorbing Indians (and their land) into the new American nation. But slavery presented fundamental problems, for slaves were by definition the enemies of masters who kept them unjustly in a state of bondage. Jefferson understood that slavery itself was an institutionalized state of war, a cold war that could turn hot whenever the balance of military power shifted against the Americans. For the thousands of slaves who declared their own independence by joining the British counterrevolutionary war effort, the liberation of their captive nation meant defeating and destroying the ruling race. Jefferson's vision of a genocidal apocalypse was not the paranoid fantasy of a pathological racist, but rather a reasonable response to geopolitical realities: "Deep rooted prejudices entertained by the whites; ten thousand recollections, by the blacks, of the injuries they have sustained; new provocations; the real distinctions which nature has made; and many other circumstances, will divide us into parties, and produce convulsions which will probably never end but in the extermination of the one or the other." It was by no means clear that white Virginians would emerge victorious. With some help from the British, the slave "party" might very well turn Jefferson's world—and the racial hierarchy that supported it—upside down. This is why it was so critical for white Americans to get rid of slavery and their slaves. This is why they had to preempt a war of national liberation—a war between

the races—by emancipating, expatriating, and declaring the independence of their former slaves. As the Haitian revolution would soon show, it would be disastrous for white Virginians if the slaves did their own declaring, and vindicated their claims on the battlefield.

In a very practical and compelling way, race constituted a particularly vulnerable boundary of American nationhood. It was most obviously vulnerable during wartime, when slaves might look for outside support. We should keep in mind that the fledgling nation did not enjoy the luxury of isolation in the first four decades of its existence, but was constantly either making war itself or attempting to preserve its tenuous neutral status in a world that was almost continuously at war. But there was another, more insidious threat, and this was that white and black Virginians would transgress the sexual boundaries that could alone sustain the distinction between their two nations or races. Jefferson's insistence on racial distinction, whether attributable to nature's original design or to "time and circumstances," stands in striking contrast to the real news from Virginia, that these two peoples were "amalgamating" into one. It is no accident that his most extended commentary on race—quoted above—is found in the Query on "Laws," for it would only be by the strict legal enforcement of racial separation that whites and blacks could be kept apart, or more precisely that the "boisterous passions" of white masters who exploited their female slaves could be restrained. The expatriation of the entire black population would require an extraordinary exercise of political will and entail a staggering cost. But perhaps this was the only way that the "lover of natural history" could really be sure that nature's will would be done.

Why was it so important to keep the races from mixing? There's much room for informed speculation here, particularly since we now know that Jefferson himself, later in life, moved freely across the sexual boundary and so helped to subvert the very racial distinctions he claimed to cherish. The simplest solution would be to recur to the now-conventional image of Jefferson as a hypocrite, drawing a sharp boundary between his immortal words and all-too-mortal flesh. It's a bigger and better challenge, however, to eschew Jefferson's own boundary-marking impulses and try to reconcile word and deed. The answer can be glimpsed, I think, in Jefferson's conception of the nation as a kind of family.

Jefferson could see the new nation as a family only in futurity. With their diverse origins, the many would become one only as they forged real bonds of kinship, marrying across the many social and cultural boundaries that limited marital choice for colonial Americans. Here was a conception of union, beginning with the union of husband and wife and widening across space and time to connect succeeding generations in a common history. These were all consensual unions, perfecting ties of reciprocal obligation, interdependent interest, shared principles and affectionate feelings. Bound so closely to each other, Americans could dispense with the heavy-handed controls and restraints of an imperial state.

But there was trouble in Jefferson's paradise. The coercive relations that constituted the institution of slavery made a mockery of consent; the uninhibited exercise of masters' sexual prerogatives produced illegitimate shadow families that straddled and subverted the ambigu-

ous boundaries between slave and free, black and white. Slavery was a debilitating cancer on the American body politic. Jefferson recommended radical surgery.

Jefferson was a racist because he was a nationalist. But nationalism, as Lincoln recognized, is not simply another word for racism, the systematic exclusion and degradation of one part of the population for the benefit of another. And Lincoln could quite properly invoke the spirit of Jefferson in calling for national renewal, a "new birth of freedom," during the dark days of the American Civil War. Jefferson's notion of the "people," we should not forget, was remarkably expansive and inclusive for its time. National feeling can be liberating and empowering, leveling traditional obstacles to pursuits of happiness among people who recognize each other—if not "all men"—as equal.

Still we are left with a feeling of Jefferson's limits and, if we are wise, of our own. It's not just that Jefferson was simply "a man of his times" and could not rise above the customs and prejudices of his slave-holding class. Jefferson did not simply discover racial boundaries already inscribed and fixed in nature: he helped construct them, contributing significantly to the racial "science" that would in subsequent decades naturalize racial hierarchy.

Jefferson was a nation-maker who helped revolutionaries see themselves as a great people with an important role to play in world history. But he was also a race-maker who defined enslaved Americans as a captive nation, an alien people who must be blotted from the face of the American earth.

Where does this all leave us in our ongoing quarrel with Jefferson's legacy, and with our own history? Perhaps in a place not unlike that of my alienated student. Sometimes we may feel that Jefferson would have considered us unwelcome aliens. More often, these days, those of us who have gotten to know Jefferson would be inclined to return the favor, to knock him off his lofty pedestal, to banish his tarnished memory from the great house that he helped build and we now inhabit.

But we cannot escape our connections with Jefferson. The anger many Americans now feel toward him testifies to the difficulty of our ongoing struggle to break the disastrous and destructive link he helped forge between race and nation. In the process we have discovered that we are not the people he imagined and that he is not the man ancestor-worshiping patriots memorialize. But Jefferson will remain a touchstone for us as long as we continue to think of ourselves as a nation.

## BIBLIOGRAPHICAL NOTE

For a fuller exposition of these themes see Peter S. Onuf, *Jefferson's Empire: The Language of American Empire* (Charlottesville: University Press of Virginia, 2000). For Jefferson's commentary on race, see his *Notes on the State of Virginia*, ed. William Peden (Chapel Hill: University of North Carolina Press, 1954). The classic study of Jefferson's changing reputation is Merrill D. Peterson, *The Jefferson Image in the American Mind* (New York: Oxford University Press, 1960).

# TODD MURPHY

STAUNTON, VIRGINIA

## Monument to Sally Hemings (cover image)

Steel, fabric
A nameless faceless monument honors Sally Hemings
Coal Tower (outside)
Corner of 10th Street East and Water Street

## Natural Histories

Mixed media
Second Street Gallery
201 Second Street NW

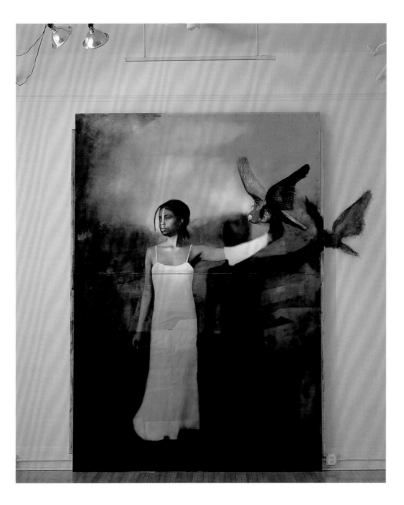

# MARTHA JACKSON-JARVIS

WASHINGTON, D.C.

## Markings

2000
Steel, concrete, plants
Montpelier, Slave Graveyard, 11407 Constitution Highway,
Orange

The unmarked slave cemetery at James Madison's Montpelier plantation home provides both inspiration and necessity for the creation of *Markings*. In the year 2000, enslaved African ancestors still mark the American landscape with their presence and power of survival. It is a story etched and encoded in the landscape for future generations to decipher and acknowledge.

The three structures in *Markings* take their influence from a distinct type of vernacular architecture called "winnowing houses," which sprang up in the southern landscape surrounding rice cultivation in the antebellum South. These stilted houses were used to separate the chaff from the grain in rice production using the wind and gravity. I view winnowing houses as symbols of the wit and ingenuity of African people who worked the land and carved emblems of survival in the landscape. The basic structure and proportions of the houses are overlaid with mythic images of animal and plant life of the region. An important gesture is made in the execution of *Markings* by symbolically lowering the stilted structures to the ground in Virginia, where tobacco was grown instead of rice. The simple house structure is used as shelter and for protection of the ancestral forces on the site.

The roof structures of the houses are built of cast concrete, with detailed carved chicken feet that serve as a textual background and symbol of sacrifice and divination. The twelve roof slabs, 2 ft. high x 4 ft. wide, are cast in pigmented concrete. Each slab is fitted precisely to the lower contours of the roof structures. Green living mosses will be encouraged to grow on the porous slabs.

Each house structure measures 4 ft. x 4 ft. x 4 ft. The interior of each is planted with native *Podophyllum* (mayapple) and *Parthenocissus quinquefolia* (Virginia creeper), a woody climbing vine that turns a brilliant blood-red in autumn. *Ophiopogon planiscapus* 'Nigrescens', an evergreen tufted black-leaved lilyturf, will be under-planted in the interior spaces to give structure and continuous presence throughout each season. The historical burial site of en-

60

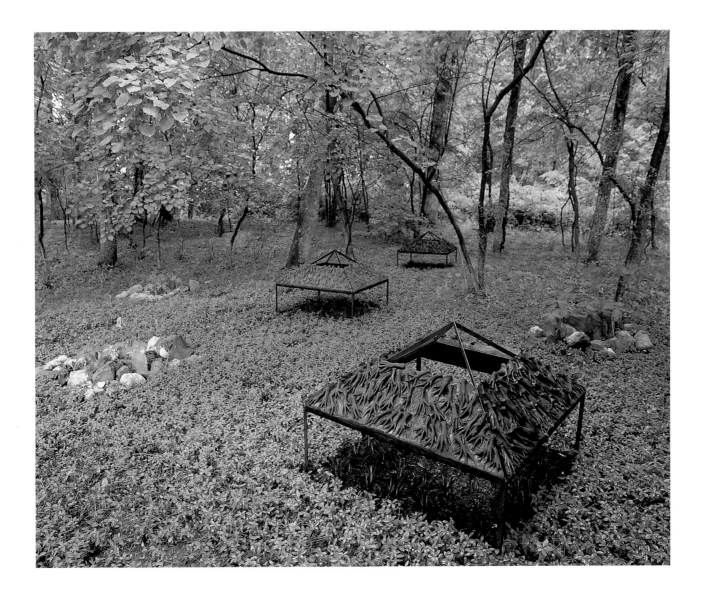

slaved African people is blanketed with a dense ground cover of *Vinca minor* (periwinkle) whose blue-violet flowers symbolize both heaven and earth.

Indigenous white quartz stones are placed in 4-ft. square mounds symbolically marking a place on this earth for all unmarked graves of enslaved and free Africans in America. As the new millennium dawns, communities will seek to distinguish the history and traditions that make them unique in the American experience. I believe that *Markings* reflects the important project of marking and telling the story of African ancestors in the history and culture of the American landscape.

# MICHAEL MERCIL

COLUMBUS, OHIO

## In My Father's House: An Historical Melancholy in Two Acts

*in collaboration with The Fabric Workshop and Museum, Philadelphia, Pennsylvania*

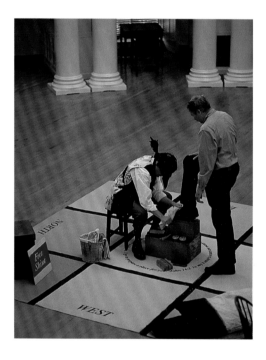

*Act I. Belongings belonging* mapped an inventory of objects at four sites in and around Charlottesville: the slave quarters at Ash Lawn–Highland, the dining room in Pavilion IX on the Lawn of the University of Virginia, the Third Street segregated African American entrance and ticket window to the Paramount Theater in downtown Charlottesville, and the Pine Room of the University of Virginia Art Museum.

The objects included a cast iron ballot box, a wooden washtub glistening with silver, a cast bronze shoe-shine box, and a set of seven cotton sleeping pallets stuffed with straw and painted with tar. Each object rested upon a square, painted floor cloth marked with one of the four cardinal compass points (north, south, east, west). A wallpaper of perching crows —after an illustration from John James Audubon's *Birds of America*—provided a backdrop. Black cotton shades with cut holes darkened the rooms.

*Act 2. Living history* was first read and performed in June 2000 at the Albemarle County Office Building, which formerly housed Lane High School. During the late 1950s, this public high school was temporarily closed as part of the statewide "massive resistance" to federally mandated desegregation laws. Here, in the central lobby of the building, a silent crow appeared. Sitting upon a square floor cloth the crow shined shoes. For free. By shining shoes the crow worked to mark a geography of social circumstance upon the map of American idealism.

*Living History* was again performed in October 2000, in the Rotunda on the grounds of the University of Virginia.

[a full statement and transcript of the play are provided in the appendix beginning on p. 83]

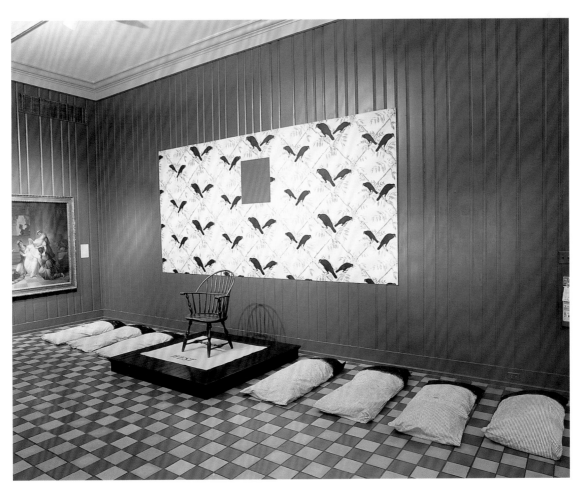

# DANIEL REEVES

EDINBURGH, SCOTLAND

## Monticello Canto

2000
Digital painting printed on canvas, suspended on exterior
brick wall, 16 ft. x 12 ft.
422 Main Street East, facing C&O parking lot, Downtown Mall

This digital painting is an allegorical tableau positing Thomas Jefferson in relation to those who were affected by the social failures and historical triumphs of his legacy. Jefferson is placed as a headmaster in the center of a twentieth-century rural Virginia school photograph and surrounded by historical figures from his era and others. Most important, he is shown along with many Native and African Americans, both the famous and the unknown, whose place in the iconic pantheon of our country has often been neglected and undermined.

At the big house there were many slaves. Slaves were negro men and women. They were brought from Africa to work on the plantations. The slaves were bought and sold like animals. They had to do just what their owners told them. Some owners were cruel. Slavery was one thing Tom Jefferson never liked. One thing Tom always liked was learning.

# DENNIS OPPENHEIM

NEW YORK, NEW YORK

## Marriage Tree

2000
Steel, fiberglass, paint
Edgehill Farm

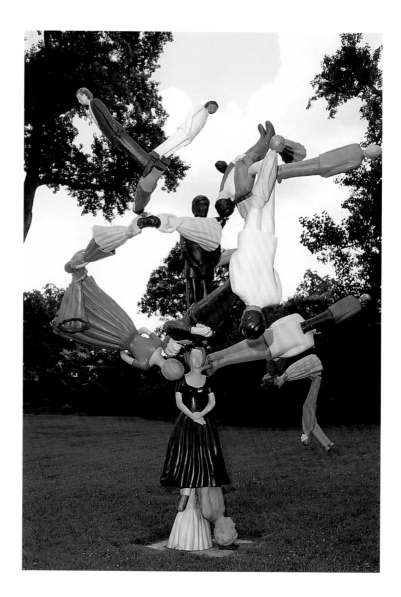

# THOMAS JEFFERSON

## AND THE NEW MILLENNIUM

### Lyn Bolen Rushton

Each generation succeeding to the knowledge acquired by all those who preceded it, adding to it their own acquisitions and discoveries, and handing the mass down for successive and constant accumulation, must advance the knowledge and well-being of mankind.—Thomas Jefferson, "Report on the Commissioning of the University of Virginia," 4 August 1818

LEARNING FROM THE PAST IN ORDER TO CREATE A NEW AND BETTER FUTURE WAS ONE OF the guiding principles of Thomas Jefferson's life and philosophy. It was also the objective of the exhibition sponsored by the University of Virginia Art Museum in the summer of 2000, "Hindsight/Fore-site: Art for the New Millennium." We shared the belief in taking an active role in history that President John Quincy Adams expressed in 1826 when he wrote, "We now receive [the Declaration of Independence] as a precious inheritance from those to whom we are indebted—to transmit the same unimpaired to the succeeding generations."[1] Idealism and an optimistic responsibility for the future have always been central to America's psyche. In Harold Bloom's words, "The United States always saw itself as the millennial nation, both before and after the American Revolution."[2]

Because Thomas Jefferson was proposed, during the "millennium-in-review fever" of the last years of the twentieth century, as the "man of the Millennium," and was regularly cited as one of the most important and influential figures of the age,[3] it was only natural to reexamine his legacy at this time in the place he called home. Charlottesville, however, was the home not only of Jefferson and his beloved University of Virginia, but also of such influential early Americans as James Madison, James Monroe, George Rogers Clark, and Meriwether Lewis. It was therefore an ideal setting for the invited artists from around Charlottesville, the country, and the world to create site-specific works that looked back at our early American history and forward into our possible futures.[4] The subjects, sites, and media chosen by these artists were

as wide-ranging as Mr. Jefferson's own encyclopedic concerns. The works dealt with such issues as interpretation itself, culture, the University of Virginia, agrarian society, nature, the "Indian Problem" (in Jefferson's words), slavery, and Sally Hemings, and the sentiments expressed ranged from biting criticism of hypocrisies in our system to grateful affirmation of its strong points.

A recurring refrain from Jefferson's most avid scholars is the admission that they have spent lifetimes researching him only to remain confounded by his enigma and the inexhaustibility of the task.[5] Tim Curtis grappled with Jefferson's "larger than life" legacy in *Visionary Spirit*, a twelve-foot-high hollow sculptural steel topcoat, modeled on those worn in Jefferson's time. Although headless and empty, the coat—with one arm crossed over its heart and a knee protruding from the seemingly wind-blown form—appeared inhabited, as powerful in its way as Rodin's *Balzac* of one hundred years earlier. For the opening ceremonies, Curtis placed the piece in front of Edgehill Farm, the house Jefferson had designed for his eldest daughter, near the rolling hills of the Shadwell area where he was born. The coat faced Monticello in its patriotic stance. As the huge form was lifted from its back in the bed of a pickup truck by a modern-day John Deere tractor, it seemed strangely as if the ghost of Jefferson were being raised from the dead. As night fell, Curtis built a bonfire within the steel coat; once lit, its embers, smoke, sparks, and flames hushed the crowd of revelers. For the remainder of the summer, the sculpture was sited prominently on a highly trafficked corner in front of the Albemarle County Office Building, where it referenced Jefferson's contributions to government. Its evening glow was now the result of electricity, marking America's shift from a rural to a technological society.

Rosemarie Fiore's *Meeting Site* also centered upon the difficulty of interpreting Jefferson, albeit with more humor and skepticism. In her performance piece, the artist and others, dressed in Indiana Jones garb, conducted an "archaeological dig" outside the Monticello Visitors' Center. Jefferson, we may recall, was often called the first modern archaeologist for his work on a Monacan Indian mound near the Rivanna river in Albemarle County.[6] Although the artist found nothing tangible in this Hollywood-inspired history pageant, she religiously dug for weeks in the hot summer sun, creating a deep, perfectly rectangular empty hole in the ground. The digging and the conversations between the "archaeologists" and visitors to the Center, who were on their own "dig" for information about Jefferson, were videotaped, shown at the University of Virginia Art Museum on a daily basis, and then buried in the hole at the close of the exhibition. For Fiore, Jefferson's legacy was the meeting of past, present, and future people and ideas, embodied in the search itself.

Ann Hamilton's *ghost—a border act* invited meditation on the place of writing in history. The installation resonated with Jefferson's spirit—his love of writing, his use of the then-revolutionary polygraph[7] and his belief in the momentous power of the pen. With his composition of the Declaration of Independence (named by many as "the pivotal document of the waning millennium")[8] for example, Jefferson forever changed (created, wrote) history. Hamilton's set-

ting was a 17,000-square-foot room filled with round steel columns in the Frank Ix building, an abandoned textile mill. Within this cavernous darkened space, she built two square rooms from transparent silk organza and placed in their centers imposing wooden tables that had originally been courtroom evidence tables. Projected onto the silk walls, a huge sharpened pencil tip wrote in a continuous illegible line across a page, clockwise in one room and counterclockwise in the other. The double image wove in and out of the columns and was reflected on the walls of the warehouse room as well as on the organza. We heard the scratching of the pencil and Hamilton's own whisper tracing what she was doing. These disembodied sounds and the placement of the image at about heart level helped to involve the viewer in a visceral, all-encompassing experience. One's walk within this space of writing was hushed and solemn, seemingly paralleling our own movement through time, and evoking the unsaid things that writing can convey only with difficulty. Jefferson and his wife, Martha, just before her untimely death, copied a passage from Laurence Sterne's *Tristram Shandy* that is remarkably apropos: "Time wastes too fast: every letter I trace tells me with what rapidity life follows my pen."[9] Hélène Cixous, a writer/philosopher Hamilton admires, writes similarly of the borders evoked in writing: "I feel close to those who have written on the edge, in transit, just after or just before. Especially written very quickly. And dying."[10]

Lydia Gasman, in her installation *Opening Closed Books,* insisted that one major factor underlay Jefferson's life and work: his *par excellence* Enlightenment belief that knowledge alone makes possible political progress. The three successive libraries that Jefferson amassed over the course of his life demonstrate its importance to his philosophy, politics, morality, and practical activity. And his own words, "knowledge is power, . . . knowledge is safety, . . . knowledge is happiness," confirm this belief that knowledge is the condition of possibility for action and positive change.[11] Perhaps taking her cue from her subject's uncompromising rationalism, Gasman uses analytical clarity and stylistic distinction in her installation to illuminate, among other things, the generally overlooked intrusion of Romanticism into Jefferson's Enlightenment thought.

A wall-sized mural in Les Yeux du Monde gallery represented Jefferson's conception of the cosmos and its relationship to the University of Virginia's architecture, while at the same time suggesting a cosmic dance of the spheres in explosive golds and blues, a Blakean god at its center. Huge texts from Jefferson's description of the classification system of his library and from his writings and those of his favorite authors were plastered over the other walls of the gallery. Sculptural freestanding reader/mirrors and a mannequin of the author/artist researching Jefferson completed the installation. The life-sized reader/mirrors underscored the importance of the viewer, who saw himself or herself in the mirror, reading and reflecting, or "absorbing and transforming," to use Gasman's words, the knowledge of the past.

Agnes Denes's *Poetry Walk: Reflections — Pools of Thought* also honored Jefferson's faith in knowledge and the creative power of the word. For this work, thought-provoking and inspiring passages written by past and present poets, politicians, philosophers, artists, dancers,

and writers, including Jefferson, were inscribed on polished granite stones and placed flat in the ground as a semipermanent artwork on the campus of the University of Virginia. Time-honored wisdom connects with reflections of today's surroundings—the reader, trees and sky. If the slabs bear a resemblance to gravestones, they also attest to the fact that the past lives in the ideas that are passed on to future generations, illustrative of Denes's belief that art can be a "great moving force that not only enhances the present but also shapes the future."[12]

Jefferson's belief in free speech (in 1790 he and James Madison successfully opposed "The Alien and Sedition Acts," which would have made it a crime to criticize government officials)[13] and the value of meaningful dialogue in a democracy were subjects for Susan Bacik, Robert Winstead, and Pete O'Shea. Each component of Bacik's *Benchmark*, a glass and steel sculpture of two benches facing one another behind a blue glass façade, is etched with one of three simple but loaded words, "ask," tell," and "listen." While the work urges contemporary visitors to sit and converse, its placement in the yard of James Monroe's Ash Lawn–Highland under a huge two-hundred-year-old oak tree recalled the importance for Jefferson of dialogue between himself and his friends. Winstead and O'Shea's *Proposal for a Monument to Free Expression*, a fifty-foot-long slate blackboard to be sited on the Downtown Mall near City Hall and recently approved by the City Council, will encourage all citizens to participate in their democracy by voicing their opinions in chalk on the board.

Lincoln Perry's eleven-panel mural, *A Student's Progress*, permanently placed in the entrance of Old Cabell Hall across the Lawn from the Rotunda, pays homage to the University, Jefferson's "hobby of his old age" and one of the three accomplishments for which he wished to be remembered (the other two were the Declaration of Independence and the Statute of Virginia for Religious Freedom). The mural follows the progress of a young female student through her academic and social life, from her arrival at the University to her graduation. The Blue Ridge Mountains painted in the background symbolically restore Jefferson's intention to leave the Lawn open, so that the students, while enclosed in an idyllic "academical village," never forgot the larger world, and in this case the natural world, beyond. Perry looked back not just to Jefferson's legacy, but also to the time-honored classical tradition as a whole. He made specific references to Raphael's *School of Athens* (1510–11), a copy of which adorns the wall in the concert hall behind Perry's mural. In this well-known painting, Raphael includes figures from the past as well as from his own time, the Italian Renaissance, placing Aristotle and Plato on the same stage as Michelangelo, for example. Likewise, Perry gives us two University notables, poet and professor Gregory Orr seated and introspective (like Raphael's Michelangelo) and art historian, artist, and philosopher David Summers standing and gazing outward beneath a statue of Thomas Jefferson.

Also using Mr. Jefferson's University as a starting point, but less idealistically, is Barbara MacCallum's *The Metamorphosis of a Scientific Article Produced in Mr. Jefferson's University*. Placed in a darkened triangular room of an old textile mill also used by Hamilton, this piece contrasted the faith in knowledge characteristic of Jefferson's time with the cynicism of the

late twentieth century. MacCallum's work was both personal and universal. Numerous copies of the first page of an academic paper written by her husband, Robert Johnson, a physics professor at the University of Virginia, were subjected to fire, ashes, and tar, then plastered into a grid/quilt form. This was hung near the back wall of the room, creating a dramatic backdrop for three life-sized empty torsos suspended from the ceiling. For these figures, the same academic paper became tortured and tainted skin, covered with fur and soot. An accompanying soundtrack played the monotone disembodied voice of Johnson reading his article. The empty torsos, though composed of words (knowledge), were powerless and vulnerable to the ravages of time, nature, and man-made disaster.

On a lighter note, Lucio Pozzi, in his *Charlottesville Color Game*, dedicated his work not so much to the past or future as to the present, taking as his canvas the entire city of Charlottesville. He created installations at the Virginia Discovery Museum (a children's museum), the grounds of St. Anne's–Belfield School, and the Frank Ix parking lot, and gave a live performance of "Reading the Newspaper" on the Downtown Mall. In keeping with the spirit of democracy and equality, he involved a wide variety of citizens of various ages in these projects, all of which shared the use of the four, for him, most banal and universal colors—red, yellow, blue, and green. Pozzi's *Parking* (four cars, each painted entirely in one of the colors) starkly called attention to the industrial "car society" America has become, very different from the agrarian society Jefferson, who dubbed farmers "God's chosen people," had envisioned.[14]

In a similar vein, Susan Crowder's *Angus,* three huge spiraling hay bales covered with asphalt, placed at the entrance of Edgehill Farm, epitomized the threat of unbridled commerce and industrialization to the agrarian life espoused by Jefferson. The entrance to this 2,400-acre working cattle farm is now ironically under an overpass to a major highway. Nevertheless, Martha Jefferson's former farm remains one of the largest tracts of undeveloped land in and around Charlottesville.

The works by Pozzi and Crowder, inviting contemplation about the metamorphosis of the pastoral landscape of Charlottesville into parking lots and highways, offer a fitting preamble to the works at Estouteville Farm, which took nature as their theme. Jefferson's architect and craftsman James Dinsmore (who also worked on the University of Virginia and Monticello) built this stately house in 1825–30. Today, the grounds and vistas remain unspoiled, much as they must have looked two hundred years ago. Thanks to the careful and spirited stewardship of the current owners, Beatrix Ost and Ludwig Kuttner, each season produces a profusion of flowering and rare vegetation, some from the original plantings.

Old-fashioned school desks painted blood-red by Ost encouraged the viewer to sit and "study nature," in the artist's words. The desks directly faced Ost's *Nature Morte,* a fallen tree painted in the same shocking red and bedecked with hanging birds' nests of all shapes and sizes. The blown glass balls that housed the empty nests spoke of preservation and extinction. Beyond this installation stood Ost's *Table of Plenty:* the visitor negotiated a labyrinth of bushes

to arrive at the center where a bright blue steel table was placed, upon which was a glass tower filled with bees busily building honeycombs. An artificial dark cloud made of black plastic netting hovered over the tower.

Also at Estouteville, sculpture by Dove Bradshaw and James Welty evoked a sense of uncertainty about the future, based on both the natural and man-made destruction of nature. In *Notation II,* Bradshaw wedged a cube of copper into a slab of Alberene soapstone found at a local quarry and left it to evolve and wear away with the weather. Appropriate are the words of one critic: "Setting in motion an open-ended process of transformation, [Bradshaw's] . . . works continue to evolve, never reaching a state of completion, but rather sliding toward entropy and disintegration."[15] Welty's organic totemic sculpture *A Short History of Decay* was composed of a copper conglomeration of deflated pods and castaway man-made objects emerging from a rounded base that resembled both a huge seed and a planet. Both works brought to mind the postmodern emphasis on devolution. Agnes Denes takes this sentiment to its possible disastrous conclusion: "We are the first species that has the ability to consciously alter its evolution, modify itself at will, even put an end to its existence."[16]

On the pavement at Estouteville, Megan Marlatt painted birds in black asphaltum, one part of her *How the Mind Travels,* which investigated aspects of the journey of Lewis and Clark. When these birds are seen in conjunction with the birds' nests in *Nature Morte* and the bees in the *Table of Plenty,* one perceives a playful reference to the "birds and the bees," fecundity and new life. Yet because the birds are merely shadows, the nests are preserved but empty, and a dark cloud shields the labyrinth, we are led to ponder more heavily the fate and role of mankind in the natural universe. Again Denes's words are relevant: "We have gotten hold of our destiny, and our impact on earth is astounding. Because of our tremendous 'success' we are overrunning the planet, squandering its resources."[17]

The journey of Lewis and Clark, under the direction of Jefferson in 1803–6, although crucial for uniting the country, would ultimately have devastating effects on the land and its original custodians, the Indians. As Stephen Ambrose wrote, "Hypocrisy ran through [Jefferson's] Indian policy, as it did through the policies of his predecessors and successors. Join us or get out of the way, the Americans said to the Indians. In fact, he stole all the land he could from Indians east of the Mississippi while preparing those west of the river for the same fate, after the beaver were trapped out."[18] Although Jefferson expressed "awe and veneration" for the Indians,[19] collecting their artifacts, and instructing Lewis to bring back as much information about them as possible (the shipment of artifacts, plants, and animals from the Mandan villages was the subject of Marlatt's collage/drawings placed in seven shallow windows of a building off the Downtown Mall), his tactics were patronizing and manipulative. For example, to a delegation of forty-five Indians from eleven tribes who went to Washington in 1806 to meet him, he said of the white man: "We are become as numerous as the leaves of the trees, and tho' we do not boast, we do not fear any nation. . . . My children, we are strong, we are numerous as the stars in the heavens and we are all gun-men."[20] This statement becomes even

more painfully ironic when we realize that the Lewis and Clark expedition would not have been successful without the assistance of the Indians at many key stages.

*Stomping Grounds: Myth Fixing and Place Making,* conceived and implemented by members of the Monacan Indian tribe of Amherst County and Dan Mahon of the Living Earth Design Group, examined, not without humor, the fate of the original inhabitants of this region and the romantic myth of the Indian as "noble savage," created in part by Jefferson. To experience this work, the viewer walked a symbolic winding path that mirrored the movement of the adjacent meandering Rivanna River (the site of Jefferson's first archaeological dig, atop a Monacan burial mound), thus reiterating the exhibition's theme of looking back and forward. The path culminated in a circle divided into four quadrants, each filled with toy plastic Indians painted in red, yellow, black, or white—the four colors used by the Monacans to represent the cardinal directions. In a performance accompanying the work, Monacan dancers and drummers in full regalia stomped the toy figures into the ground, symbolizing the end of a stereotype of a people who had endured a history of being "walked on." At the time a tribal chief reminded us, "If we had been the savages, we would have killed you when you came here. It seems to have been the other way around." He also linked the successes of our nation to the Native American foundation upon which it was built: "Great things happen when one stands on a great one's shoulders."[21]

Daniel Reeves's *Monticello Canto,* a huge digital print on cloth exhibited on a brick wall just off the downtown pedestrian mall, explored the gross contradictions inherent in Jefferson's legacy, and the length of time it has taken for our country to right some of its wrongs. Against a psychedelic background that melded images of Monticello with those from the first walk on the Moon, Reeves placed a black-and-white school photo from the 1920s. Over the original faces were superimposed those of historic figures, from Thomas Jefferson in the center to Marie Antoinette, Ben Franklin, and Martin Luther King, along with lesser-known faces of all ethnic backgrounds. The moonscape begs the question: As far as we have come technologically, have we kept up socially?

This is one of the questions that Michael Mercil addressed within his multilayered *In My Father's House: An Historical Melancholy in Two Acts.* Mercil's work points out how far we still are from Jefferson's declaration of 1776 that "all men are created equal" or from his 1823 affimation that the "only legitimate object of government is the equal rights of man, and the happiness of every individual."[22] The backdrop against which Mercil creates his work offers a different reality—what the artist dubs "our distinctly deformed social history (i.e. de facto social divisions of slavery and, later, of celebrity culture). Inequality for all" (see the appendix, p. 83). For *Act 1. Belongings Belonging,* Mercil placed four mundane yet socially charged objects—a bronzed ballot box, a shoeshine kit, a washtub and sleeping pallets—in four sites in and around Charlottesville. Three of the sites he originally wished to use—Jefferson's Poplar Forest retreat, James Madison's Montpelier, and Hotel C on the West Range of the University, now used for the University of Virginia Debating Society—were not made available to him.[23]

Proprietors of each claimed that Mercil's objects did not "belong" in their historic rooms, thus underlining the remaining difficulty in making room for alternative ways of seeing and interpreting history. *In Act 2. Living History,* the past also merged with the present in an unsettling way. The belongings were gathered onto a huge floor cloth resembling a gameboard, and the crow/artist sat at its center shining shoes for free. The crow is often seen as a symbol of evil and blackness; as John James Audubon wrote, "Almost every person has an antipathy to him."[24] In this instance the crow also referenced the "Jim Crow Laws" (named after a minstrel show character), which promoted segregation as late as the 1960s. The piece evoked, as Mercil intended, "a shared public memory,"[25] and aspects of our own history too often forgotten. Of Charlottesville, the artist wrote: "The social disunity of slavery is everywhere apparent yet remains invisible. Not unremarked but still unmarked" (see appendix, p. 83).

The slave cemetery at James Madison's Montpelier is one such "unmarked" place, or was until Martha Jackson-Jarvis constructed *Markings.* At first glance the cemetery seemed like any other overgrown plot in the woods. Gradually, one detected white quartz stones marking the graves. Next to this in the woods, Jackson-Jarvis placed three four-foot-square houses built of a black steel armature topped by concrete slab roofs, and four four-foot-square piles of quartz stones. She planted rare black mondo grass inside the houses in a grid form. Springing through the piles of quartz were the large leaves of a trillium plant, whose long association with the cross evoked a metaphor of sacrifice and suffering. Just as the original stone markers of the graves are barely visible, covered with periwinkle and weeds, the ensemble by Jackson-Jarvis became one with its surroundings as a living homage to the dead.

Several artists entered the continuing controversy surrounding Jefferson's personal life, which revived following the 1998 report based on DNA evidence that Jefferson had probably fathered at least one of Sally Hemings's children.[26] Although there are no extant images of Hemings, she took center stage in Todd Murphy's paintings at Second Street Gallery and his elegant sculpture, *Monument to Sally Hemings,* an ethereal billowing white dress draped over a dressmaker's mannequin, placed atop the coal tower (symbol itself of blackness and blue-collar work). This sculpture proved a lightning rod for scholars and townspeople alike, and was repeatedly vandalized and torn to shreds during the course of the summer. With views of Monticello in its background and visible from many points in Charlottesville, *Monument* constantly changed, paralleling the continually shifting interpretations of Hemings and commemorating her contradictory and lasting place in American history.

Although Dennis Oppenheim chooses to let his work speak for itself, his *Marriage Tree* can be seen as referencing the Jefferson-Hemings controversy. At the base of the "tree" is an upside-down bust of a gray man (Jefferson) back to back with an upside-down torso of a black woman. Atop these figures, forming the trunk, is a strong full-sized woman (seen by some viewers as a figure of Jefferson's daughter Martha, from whom the two are hiding, literally under her skirt!)[27] Sprouting from this trunk are many colored fiberglass life-sized brides and grooms, modeled on wedding cake decorations and arranged head to head and feet to feet

in a formation reminiscent of a magnified DNA molecule.[28] While its Disneyland conception seems to poke fun at the sensationalism of the controversy, the sculpture's placement amidst the huge Jefferson-era tulip poplars at Edgehill and its inescapable parallels with the Tree of Life remind us of the underlying unity of humanity.

The artists in *Hindsight/Fore-site* variously called attention to the ambiguities in Jefferson's legacy, to the crucial role culture plays in guiding our actions on this planet, and to the importance of living in harmony with nature and one another. Whether focusing on past triumphs or defeats, they all offered insights into our shared American past, inviting contemplation about our current place in history and hopes for the future.

## NOTES

1. Quoted in Andrew Burstein, *America's Jubilee* (New York: Knopf, 2001), 4.

2. Harold Bloom, *Omens of the Millennium* (New York: Riverhead Books, 1996), 41.

3. "Man of the Millennium, Man of the Century, Man of the Moment," *Monticello* 11, no. 1 (spring 2000). George Will called Jefferson the "man of the millennium." He wrote in 1990 that "the argument for Jefferson is that history is the history of the human mind of ideas. Jefferson was, preeminently, the mind of the Revolution that succeeded. It resulted in the birth of the first modern nation, the nation that in the 20th century saved the world from tyranny" (qtd. ibid.).

4. This essay will discuss twenty-two of the artists. Not included are William Bennett, who was represented in the exhibition by a model of a work he had expected to build on the site of Ash Lawn–Highland (permission was never granted) and high school students who created biographical videos as part of a course they took at Lighthouse, a local media program.

5. Fawn Brodie, *Thomas Jefferson: An Intimate History* (New York: Norton, 1974), 32, 57–58.

6. Silvio A. Bedini, *Thomas Jefferson: Statesman of Science* (New York: Macmillan, 1990), 105, 280. Thomas Jefferson meticulously reports on this excavation in *Notes on the State of Virginia* (London: John Stockdale, 1787), 102–3.

7. Bedini, *Thomas Jefferson*, 117, 127.

8. "Man of the Millennium."

9. Andrew Burstein, *The Inner Jefferson: Portrait of a Grieving Optimist* (New York: Knopf, 1995), 3.

10. Hélène Cixous, "In October 1999 . . . ," in *Stigmata Escaping Texts* (New York: Routledge, 1998), 47, 49.

11. Thomas Jefferson to George Ticknor, 25 November 1871, qtd. in Dumas Malone, *Jefferson and His Time*, vol. 6, *The Sage of Monticello* (Boston: Little, Brown, and Co., 1981), 201.

12. Agnes Denes, "Notes on Eco-Logic: Environmental Artwork, Visual Philosophy and Global Perspective," *Leonardo* 26, no. 5 (1993): 387.

13. John Whitehead, "Free-Speech Board a Lesson in Liberty," *Charlottesville Daily Progress,* 25 February 2001, sec. D, p. 1.

14. Brodie, *Thomas Jefferson,* 264. Illustrating the importance Jefferson attached to agriculture is his letter to David Williams in 1803: "Agriculture . . . is a science of the very first order. It counts among its handmaids the most respectable sciences, such as Chemistry, natural Philosophy, Mechanics, Mathematics generally, Natural History, Botany" (qtd. in Bedini, *Thomas Jefferson,* 249).

15. Collette Chattopadhyay, "Los Angeles: Dove Bradshaw," *Sculpture* (January–February 1999).

16. Denes, "Notes," 387.

17. Ibid.

18. Stephen E. Ambrose, *Undaunted Courage* (New York: Simon & Schuster, 1996), 338.

19. Brodie, *Thomas Jefferson,* 36.

20. Ambrose, *Undaunted Courage,* 341.

21. Johnny Johns, Darden Towe Square Park, August 12, 2000.

22. Thomas Jefferson to A. Coray, 31 October 1823, *The Writings of Thomas Jefferson,* ed. Albert Ellery Bergh (Washington, D.C.: Thomas Jefferson Memorial Association, 1905), 15:480–82.

23. Michael Mercil, private correspondence, April–May 2000.

24. John James Audubon, *Ornithological Biography,* ed. Christopher Imscher (New York: The Library of America, 1999).

25. Michael Mercil, "Democratic Vistas: American Front Yards as Public Space—A Landscape History to 1900" (M.F.A. thesis, University of Chicago, May 1988), 2.

26. The affair, although first mentioned in 1802 in a newspaper attack on Jefferson, was for the most part successfully denied throughout the next two hundred years. Fawn Brodie brought the controversy up in her book *Thomas Jefferson: An Intimate History,* which was much maligned by major scholars at the time. The issue resurfaced on October 31, 1998, when Dr. Eugene Foster and a team of European geneticists concluded, based on DNA evidence, that Eston Hemings, born in 1808, was the son of a Jefferson male and Hemings; Eugene Foster, "Jefferson Fathered Slave's Last Child," *Nature* 396 (November 5, 1998). The Thomas Jefferson Memorial Foundation published a report on January 26, 2000, that agreed with Foster's conclusions, giving other strong circumstantial evidence supporting Thomas Jefferson as the likely father not only of Eston but of the other Hemings children as well. Not surprisingly, this was immediately contested by a group that initially called itself the Thomas Jefferson Foundation (before being legally required to change its name because it was misleading).

27. Greg Graham, owner and steward of Edgehill Farm shared with me this apt interpretation (especially given the site), which would also mesh easily with Oppenheim's penchant for humor.

28. Germano Celant, *Dennis Oppenheim* (New York: Abrams, 1983), 36, 51. This interest in genetics has been latent in Oppenheim's works since the 1970s, when he did projects that in his words "function within the arena of genetic extension." He created *Shadow Projection* after his father died, and collaborated on art with his children when they were young. Oppenheim also spoke of "genetic invasion" in reference to some of his works of the early 1980s.

# ROSEMARIE FIORE

NEW YORK, NEW YORK

## Meeting Site

April–June 2000
Performance piece (including excavation, videotapes)
Monticello Visitor Center

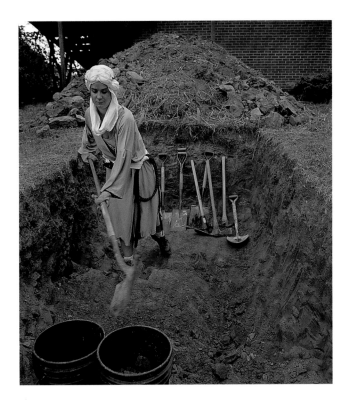

*Meeting Site* was a performance designed to evoke conversations with tourists visiting the historic site Monticello, the home of Thomas Jefferson. Dressed in garb inspired by Hollywood's most famous fictional archaeologist, Indiana Jones, who searched for mythical objects, I dug for something non-material: Jefferson's enlightenment. It was a futile dig; only large boulders were uncovered. At designated times during the entire summer a video camera recorded tourist interaction with others and myself as we excavated. At the conclusion of the dig, all these tapes, with the comments and thoughts of hundreds of visitors to Jefferson's home, were placed in the deep hole and buried.

# TIM CURTIS

MIAMI, FLORIDA

## Visionary Spirit

Welded steel, mulch, stones, boulders, height 13 ft.
Front lawn, Albemarle County Office Building,
401 McIntire Road, at Preston Avenue

I am examining Thomas Jefferson's continued influence on contemporary thinking and governmental practices. My goal is to remind us of Jefferson's lingering influence by examining his absence. *Visionary Spirit* is intended to represent the spirit of Jefferson; hence, this site-specific work is figural rather than figurative. Viewers are presented with an abstract rendering of a nineteenth-century outer garment of a sort fashionable during Jefferson's presidency. Welded steel strips form the "fabric," creating a dynamic vertical twisting pattern. Standing thirteen feet tall, this animated garment appears to be inhabited, thus representing the heroic quality of Jefferson's legacy. In addition to the steel garment, mulch, stones, and boulders have been incorporated into the landscape. These earthen elements, which cascade from the figure out onto the lawn, are intended to symbolically suggest Jefferson's love for and connection to the Virginia landscape. The mulch also makes a visual and symbolic connection between the sculpture and the site. While the trees receive nutrients enabling them to thrive, the sculpture is intended to nurture the spirit of Jefferson within the community.

At dusk during the opening ceremonies the spirit of Jefferson was rekindled by creating a large bonfire within the garment, which was temporarily sited at Edgehill Farm. The resulting flames, cinders, and smoke rising in the sky symbolically reconnected us to our past. Our ancient ancestors were fascinated with the power and magic of fire, just as we are today. Fire is a primal force associated with both destruction and rebirth. Native Americans set fires on the open plains to control the grasses, and certain pine seeds will not germinate until their cones are charred by fire. It is part of the natural cycle in many regions of the world. This performative aspect of the project created a unique shared experience for those in attendance. Every evening thereafter the sculpture is illuminated from the inside, creating a warm inviting glow.

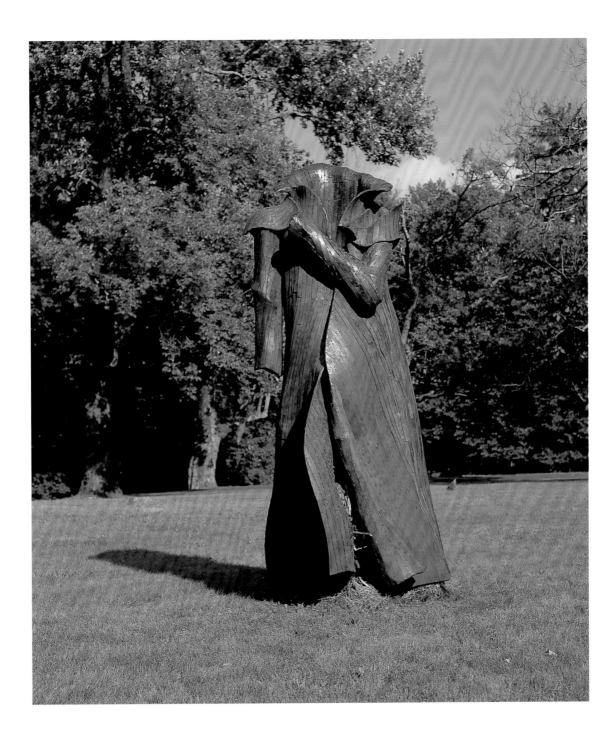

# ANN HAMILTON

COLUMBUS, OHIO

---

### ghost—a border act

Silk organza enclosures, spinning video projection, twin tables
and chairs, sound.*
Frank Ix Building, 531 Ware Street

*Courtesy of Sean Kelly, New York*

To        d e l i n e a t e

The inscription of a line, wound, round, an enclosure
It announces, fixes, establishes, marks, a visible trace
It is a word, a name, a signature
Roving the border between
A hiss sounding the silence of
A dividing from
A dividing by
Erasures
History.

Between a reader and a writer

*Sound made with Andrew Deutsch at the Institute for Electronic Media at Alfred University

Project volunteers: Marty Chafkin, Catherine Dee, Andrew Deutsch, Will Kerner, Monica McTigh, Maggie Moore, Kristen Nyce, and Brooke Singer.

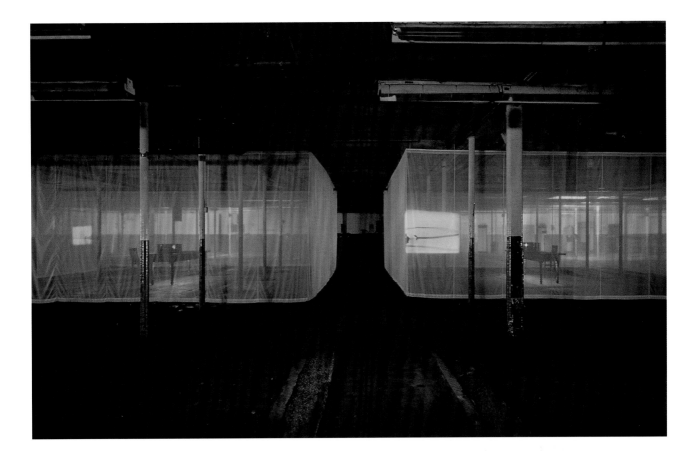

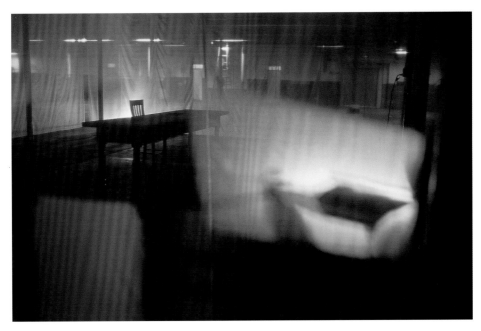

# APPENDIX

---

## In My Father's House: An Historical Melancholy in Two Acts

Michael Mercil

PROPOSAL

Belongings (an inventory)

All I have:     —washtub

               —shoeshine box

               —sleeping pallet

               —ballot box

rattling around in the attic of American history;

mansion house/slave house/jail house/hospital.

At Montpelier plantation there is very little stuff beyond Dolley Madison's snuffbox, but there is a lot of display.

The main house at Ash Lawn plantation is chock-a-block with stuff. Most of it, however, was never owned by the Monroes, even if, as we are told, "it is something like they would have had."

I started out thinking about Thomas Jefferson, and the gridding of the American landscape. Philip Fisher's writing got me thinking about the uniform abstraction of the land survey grid as a mechanism for unifying American social experience, and about our distinctly deformed social history (i.e. de facto social divisions of slavery and, later, of celebrity culture). Inequality for all.

But it's impossible to see the grid from Charlottesville. The Appalachian mountains block the view. The grid only begins on the other side, in Ohio—my current home state. In Virginia the disunity of slavery is everywhere apparent, yet it remains invisible. Not unremarked, but still unmarked.

I mentioned Dolley Madison's snuffbox. The location of the slave quarters (called only "quarters") at Montpelier is mapped, but not marked in any way. So we can see the snuffbox

that Dolley once hid in her satchel, but the housing of the slaves, who presumably made and served "Dolley's" ice cream (surely she herself did not actually make or serve it) remains out-of-sight. How was that little silver box found, but those houses lost?

The Madison family graveyard is currently being restored, while nearby the foundation to the family's original dwelling is carefully being uncovered. Wandering farther down the road and around a bend, we can peer into an opening in the woods and discern the low depressions and scattered stones that mark the grave sites of forty or so unnamed African Americans.

Do not those enslaved also count, if only cruelly so, as part of the inventory of American experience? Perhaps the difficulty is where, within our present experience, to place them? It was not difficult then. Read the accountings and the wills. There, alongside the careful itemizing of furniture, buildings, livestock and other belongings, we can find the lists of names.

An objection might be that, since the Civil War, haven't we all suffered enough? Isn't that all behind us? That was then. This is now. But, even if only incompletely, isn't our goal when visiting such sites as Montpelier to bind its history to our own? And to assure ourselves that the heritage of the Madisons, the Monroes, and the Jeffersons is not, in fact, singular, but through us is made numerous?

At Ash Lawn, we can see the quarters behind the house. They are small, neat, and trim. They would have been too crowded to be cozy, but they do have stone chimneys and foundations and wood floors. They have paned glass windows. The walls are plastered and white-washed, or now, they are Sheetrocked and painted. On one wall a historical note records an early visitor's remark on the "uncommon decency" of these quarters compared to what was typical. Should we then suppose that Ash Lawn was also a happier place?

At Mount Vernon, George Washington schemed to rid himself of his slaves. Slavery, it seems, interfered with the commander's sense of both economy and virtue. This isn't to claim for Washington a fundamental concern for the happiness of his slaves, but rather to acknowledge his recognition of the unhappy contradictions of slavery as a system. His solution was to rent part and sell some of his land holdings. With a fixed income Washington hoped to free his slaves and, thereby, to free himself of slavery. But he found no takers. He remained a slaveholder until he died. Then, in accordance with his will and purpose, both George Washington and his slaves were freed at last.

At Monticello, with Thomas Jefferson, things — *all* things — were much more complicated. But is that contradictory to his character? Only look round the house. An interesting note: two of the Hemings-Jefferson children settled in Ohio. Some of their descendants live right here in Columbus. Last week, I met Shay Banks-Young — who is black — and her cousin, Julia Jefferson Westerinen — who is white. Their great-great-grandfathers were the Hemings brothers, Eston and Madison.

But I have not proposed to work at Monticello.

My other interest has been Hotel C on the West Range of the University of Virginia

grounds. This beautifully proportioned room is watched over by rather sullen portraits of Jefferson, Robert E. Lee, J. E. B. Stuart, Woodrow Wilson, and King James I. It is home, since 1825, to the Jefferson Debating & Literary Society. During the Civil War it was used as a hospital. A site of woundedness and healing.

I am reminded of the poet Walt Whitman working in the hospitals in Washington, D.C., and of his poem *The Sleepers,* which conjures a state of human commonality:

> How solemn they look there, stretched and still;
> How quiet they breathe, the little children in their cradles. . . .
> The blind sleep, and the deaf and dumb sleep,
> The prisoner sleeps well in the prison. . . . the runaway son sleeps,
> The murderer that is to be hung the next day. . . . how does he sleep?
> And the murdered person . . . . how does he sleep?
>
> The laugher and weeper, the dancer, the midnight widow, the red squaw,
> The consumptive, the erysipalite, the idiot, he that is wronged,
> The antipodes, and every one between this and them in the dark,
> I swear they are averaged now. . . . one is no better than the other,
> The night and sleep have likened them and restored them. I swear they are all beautiful,
> Everyone that sleeps is beautiful. . . . every thing in the dim night is beautiful,
> The wildest and bloodiest is over and all is peace. . . .
>
> The diverse shall be no less diverse, but they shall flow and unite . . . . they unite now.
>
> The sleepers are very beautiful as they lie unclothed,
> They flow hand in hand over the whole earth from east to west as they lie unclothed;
> The Asiatic and African are hand in hand. . . . the European and American are hand in
>     hand,
> Learned and unlearned are hand in hand . . the male and female are hand in hand;

I would empty Hotel C of its paintings and chairs. I would empty the Madison dining room at Montpelier. At Ash Lawn, I would empty a room of the slave quarters. I would replace their current inventories with singular items recalling unmarked histories.

> inventory:  —washtub
>           —shoeshine box
>           —sleeping pallet
>           —ballot box
> rattling around in the attic of American history;
>
> mansion house/slave house/jail house/hospital.

But this emptying out no longer seems reasonable or possible. It is not a matter of replacing history, but of placing it. Or, perhaps, my question is how to place myself within this his-

tory. Do I need to bring this stuff with me? How can this stuff stand for/in history? Do I suppose this stuff, in some way, should stand for me? Do I need to place myself there? To, quite literally, stand there myself? Belongings belonging. Living history.

> In my Father's house are many mansions: if it were not so I would have told
> you. I go to prepare a place for you.                                    —John 14:2

SCRIPT

Company:
Narrator: Bill Bergen (June); Theresa Dowell-Vest (October)
Reader #1: Kara McLane (June); Clinton Johnston (October)
Reader #2: Bruce Nelson (June); Jennifer Hoyt (October)
Reader #3: Jennifer Hoyt (June); Bill Bergen (October)
Reader #4: Hee Jong Oh (June); Kara McLane (October)
Crow

NARRATOR  IN MY FATHER'S HOUSE
      an historical melancholy in two acts.
      Act 1. Belongings belonging.
      Act 2. Living history.

*Prologue*

ALL    We camp awhile in the wilderness,
      In the wilderness, in the wilderness;
      We camp awhile in the wilderness,
      Where the Lord makes me happy,
      And then I'm a-going home!

NARRATOR  ACT 1. Belongings belonging

      Belongings:  —washtub
             —ballot box
             —sleeping pallet
             —shoeshine box

      belong to/in  —mansion house
             —slave house
             —hospital
             —school house
             —courthouse/jail house/counting house/movie house.

The ground for these belongings is a grid of floor cloths. The background for these belongings is a murder of perching crows. The rooms for these belongings are darkened. There is no clear meaning. Perhaps there is no meaning. Or there is nothing to make meaning from or sense of. There is only senselessness. Our memory is not clear. It is dimmed. For some there is no memory, or worse, only false memory. For others the only memory that will do is to forget.

These belongings come from no particular place. Their history is not individual, but general. They come from anywhere and belong to everywhere. One paradox of the visual arts is the use of shadow to depict light (to project the illusion of form). To be made visible these belongings, likewise, will be placed in shadow. These belongings are not "a real find." They are my real search. Searching through, or in, my Father's house,

ALL  I wander all night in my vision
    Stepping with light feet. . . . swiftly and noiselessly stepping and stopping,
    Bending with open eyes over the shut eyes of sleepers;
    Wandering and confused. . . . lost to myself . . . ill assorted. . . . contradictory,
    Pausing and gazing and bending and stopping.

                  —Walt Whitman, *The Sleepers*

NARRATOR  It is a paradox of our particular history that this house stands upon both slavery and freedom. This paradox is not a regional one. North, South, East, West, it is our national legacy. As historian Philip Fisher says of democratic social space, "[A] society cannot be undivided unless it is undivided everywhere; but it is divided, if it is divided anywhere. Slavery in the South made it true that every Northerner was, in effect, a member of a slave-owning society." Or as more directly described by Patsy Mitchner, a former slave from North Carolina:

ALL    "Two snakes full of poison. One lying with his head pointing north, the other with his head pointing south. Their names was slavery and freedom. The snake called slavery lay with his head pointing south, and the snake called freedom lay with its head pointed north. Both bit the nigger, and they both was bad."

NARRATOR  So the scene of our historical melancholy is set . . .

READER #1  —In my father's house at Ash Lawn Plantation is a ballot box of iron—

The iron box is placed on the floor in one room of the slave quarters. It sits on a square painted floor cloth. One wall in the room is papered with images of crows from John James Audubon's *Birds of America*. Black cotton shades cut with round holes cover the windows. Throughout the day beams of sunlight scatter across the floorboards and up the walls. The room, otherwise, is unlit.

READER #2  —In my father's house at Montpelier Plantation is a shoeshine box in bronze—

Dressing a scene of many Madison family entertainments, the shoeshine box is set in a corner of the veranda facing the back lawn of the Big House. A single black windowshade hangs from the glassed doorway that opens to the porch. It is a modest presentation. But there is no room for the shoeshine box at Montpelier Plantation. It can be found at the Third Street entrance to the Paramount Movie Theater in downtown Charlottesville.

READER #3     —In my father's house at Poplar Forest is a wooden washtub—

One finds the washtub on the floor in Thomas Jefferson's reading room. The tub appears filled with shimmering silver water. A fragment of the wallpaper hanging in the quarters at Ash Lawn here covers a screen set before the hearth place. Black shades with holes darken the parlor windows. But there is no room for a wooden washtub in Poplar Forest. It rests in Pavilion IX at the University of Virginia.

READER #4     —In my father's house at the University of Virginia is a painted sleeping pallet—

Hotel C, on the West Range of the University grounds, is home, since 1825, to the Jefferson Debating Society. During the Civil War this room was a hospital. No object is placed here. But the back wall, behind the raised platform, is covered with the wallpaper of crows; and black cotton shades hang from the windows. The framed photographs on the wall are removed, but the portrait of Thomas Jefferson remains—as do all the other furnishings. The room continues to be used for events organized by the Debating Society. Other times it is closed. But Hotel C has no place for the wallpaper of perching crows.

The papered wall from Hotel C appears, instead, in the Pine Room of the Bayly Museum. The location of the Jefferson portrait is left blank. Beneath the absent painting a chair sits on a raised platform. On the floor, beside the platform, lie seven sleeping pallets. They are made of common cotton ticking, stuffed with straw and painted with tar.

NARRATOR     ACT 2. Living History

ALL     *Corvus americanus*
          The crow is an extremely shy bird, having found familiarity with man in no way to his advantage. He is also cunning—at least he is so called, because he takes care of himself and his brood. The state of anxiety, I may say of terror, in which he is constantly kept, would be enough to spoil the temper of any creature. Almost every person has an antipathy to him, and scarcely one of his race would be left in the land, did he not employ all his ingenuity and take advantage of all his experience, in counteracting the evil machinations of his enemies.
                    —John James Audubon, *Ornithological Biography*

NARRATOR     A crow wanders from place to place. Being extremely shy the crow says nothing, but sits upon a floor cloth shining shoes. For free. The floor cloth circumscribes an arena for this exchange. But if the shoeshine is free and no money is exchanged, and if the crow is shy and no words are exchanged, then what is the nature of the crow's transaction?

If there is no charge, then is there no customer? Yet there is one who labors and another who receives that labor. If there is no charge, then is there no cost? How then to measure the value of the shoeshine? And how to measure the value of the crow? How is the crow to be(come) recognized? How is the crow to be(come) perceived?

ALL     *What the Crow Said*
Though friendly to magic
I am *not* a man disguised as a crow.
I am night eating the sun.

　　　　　　—Michael Hannon

NARRATOR     The more questions asked the farther away seems any answer. "Farther away" describes a distance. But before this distance can be bridged it must be marked. By shining shoes the crow works to mark the distance. The mark of this distance is left on the cloth that shines the shoes. It is the mark of a social divide, or gap, or tear. But is to mark this distance to bridge the divide?

When shining shoes the crow is, literally, under foot. It is here, under foot, where the transaction with the crow takes place. A foot is lifted to the platform of the shoeshine box, and the crow reaches to touch, cradle, and shine the shoe. From underfoot the divide is bridged.

　　　　　What is exchanged is not words.
　　　　　What is exchanged is not things.
　　　　　What is exchanged is not money.
　　　　　What is exchanged is touch.

The exchange with the crow is a social transaction.

ALL     As members of human society, perhaps the most difficult task we face daily is
　　　　that of touching one another—whether touch is physical, moral, emotional
　　　　or imaginary. Contact is crisis. As the anthropologists say, "Every touch is a
　　　　modified blow."　　　　　　　　—Anne Carson, *Men in the Off Hours*

NARRATOR     Epilogue

North, South, East, West the grid is made whole, and the scattered belongings of the crow are gathered together. Shoes are shined. For free. Yet the gap, the rift, the tear still cannot be mended. And memory, like the crow, is absent.

ALL   We camp awhile in the wilderness,

In the wilderness, in the wilderness;

We camp awhile in the wilderness,

Where the Lord makes me happy,

And then I'm a-going home!

## BIBLIOGRAPHY

Audubon, John James. *Writings and Documents.* Ed. Christopher Irmscher. New York: The Library of America, 1999.

Carson, Anne. *Men in the Off Hours.* New York: Alfred A. Knopf, 2000.

Fisher, Philip. "Democratic Social Space: Whitman, Melville, and the Promise of American Transparency." In *The New American Studies: Essays from "Representations."* Ed. Philip Fisher. Berkeley: University of California Press, 1991.

Guss, David M., ed. *The Language of the Birds: Tales, Texts, & Poems of Interspecies Communications.* San Francisco: North Point Press, 1985.

Hurmence, Belinda, ed. *My Folks Don't Want Me to Talk about Slavery: Twenty-one Oral Histories of Former North Carolina Slaves.* Winston-Salem: John F. Blair, 1984.

Whitman, Walt. *Selected Poems 1855–1892.* Ed. Gary Schmidgall. New York: St. Martin's Press, 1999.

# NOTES ON THE ARTISTS

**SUSAN BACIK** (b. 1959)   CHARLOTTESVILLE, VIRGINIA

Susan Bacik studied at the University of Minnesota and Pendle Hill Quaker Study Center, Wallingford, Pennsylvania. She has worked on a farm, and as a lifeguard, house painter, university guest lecturer, art gallery assistant director, television host, writer and producer. In 1998 she received a grant from the Virginia Commission for the Arts for an exhibition of "The Scale Series and The Oracle Series" at the University of Virginia Art Museum. Her work is held in public collections at the University of Virginia Art Museum and Pendle Hill Quaker Study Center. Ms. Bacik's solo exhibitions include "The Camouflage Series," Thomas Jefferson Center for the Protection of Free Expression, Charlottesville, (1996); "The Truck Series," WARM Gallery, Minneapolis (1985); and "The Shroud Series," also at WARM Gallery (1982). Her group exhibitions include "The Constructed Image," Leighton House Museum, London (1991); "Three American Views," Knapp Gallery, London (1990); and "A Landmark Exhibition," Minnesota Museum, Saint Paul (1984). She has also participated in group exhibitions at the General Mills World Headquarters Gallery (1982) and at the University of Minnesota Gallery (1980), both in Minneapolis.

SELECTED BIBLIOGRAPHY

Balge-Crozier et al. *Susan Bacik: Weighing the Immeasurable, Asking the Unanswerable: The Scale Series and the Oracle Series.* Charlottesville, VA: Bayly Art Museum, University of Virginia, 1998.

*Warm: A Landmark Exhibition.* Minneapolis: Women's Art Registry of Minnesota, 1984.

**DOVE BRADSHAW** (b. 1949)   NEW YORK, NEW YORK

Dove Bradshaw received her B.F.A. from the Boston Museum School of Fine Arts in 1973 and taught at the School of Visual Arts, New York, from 1977 to 1981. In 1975, she was awarded a National Endowment for the Arts fellowship and in 1985 she received a Pollock/

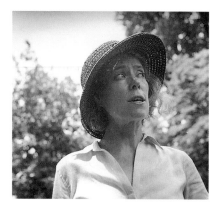

Krasner Award. Her work is represented in numerous public collections, including the Metropolitan Museum of Art, New York; Museum of Modern Art, New York; Whitney Museum of American Art, New York; the Art Institute of Chicago; Museum of Contemporary Art, Los Angeles; National Gallery of Art, Washington, D.C.; Centre Georges Pompidou, Paris; Kunstmuseum, Düsseldorf; Moderna Museet, Stockholm; Museum of Art, Bilbao; and Pier Center, Orkney, Scotland. Locations of Ms. Bradshaw's solo exhibitions include Stark Gallery, New York (2000); Larry Becker Contemporary Art, Philadelphia (2000); Stalke Gallery, Copenhagen (1995, 1996, 1998, 1999, 2000); the Mattress Factory Museum, Pittsburgh (1990, 1999); Sandra Gering Gallery, New York (1988, 1989, 1991, 1993, 1995, 1998); Museum of Contemporary Art, Los Angeles (1998); Barbara Krakow Gallery, Boston (1997); and P.S. 1 Museum, New York (1991). She has participated in numerous group exhibitions, including ones at the University of California, San Diego (1999); Whitney Museum of American Art, New York (1997); Carnegie Museum of Art, Pittsburgh (1997); Art Institute of Chicago (1996, 1992); Philadelphia Museum of Art (1993, 1996); Swiss Institute, New York (1995); The Metropolitan Museum of Art, New York (1992); Carnegie International, Pittsburgh (1990); and Museum of Modern Art, New York (1989).

SELECTED BIBLIOGRAPHY

Bradshaw, Dove. *Indeterminacy.* Stromness: Pier Gallery, 1995.
———. *Nothing: Electrostatic Prints.* New York: D. Bradshaw, 1988.
*Dove Bradshaw: Works, 1969–1993.* New York: Sandra Gering Gallery, 1993.
Kwal, Teri, and Michael Gamble. *Contacts, Communicating Interpersonally, She Knows the Value of a Smile.* New York: Random House, 1981.
Lazar, Julie. *Dove Bradshaw, Jan Henle.* Los Angeles: Museum of Contemporary Art, 1998.
McEvilley, Thomas. *Sculpture in the Age of Doubt.* New York: Allworth Press, 1999.

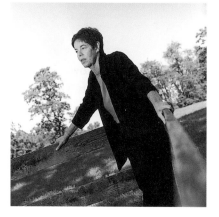

## SUSAN CROWDER (b. 1943)  CHARLOTTESVILLE, VIRGINIA

Susan Crowder received her B.A. from Sweet Briar College in 1965 and studied at a variety of institutions between 1964 and 1972. In 1998, she received her Landscape Design Certificate from the Morris Arboretum, University of Pennsylvania. She has taught as a visiting artist/artist-in-residence at the Pennsylvania Academy of Fine Arts, Philadelphia; Germantown Academy, Fort Washington, Pennsylvania; and Lafayette College; and given lectures at various institutions and conferences. Ms. Crowder's grants and awards include the Purchase Award, Philadelphia Museum of Art (1998); Sculpture Achievement Award, Chesterwood, Stockbridge, Massachusetts (1996); National Endowment of the Arts ("Formal Garden," Laumeier Sculpture Park, St. Louis) (1992); and Residency Fellowships, Virginia Center for the Creative Arts, Sweet Briar (2002, 1984). Her work is represented in the collections of Fort Wayne Museum

of Art, Indiana; Grounds for Sculpture, Hamilton, New Jersey; Indianapolis Museum of Art; Laumeier Museum and Sculpture Park, St. Louis; National Museum of Women in the Arts, Washington, D.C.; Newark Museum of Art, New Jersey; and the Philadelphia Museum of Art. Crowder has participated in numerous public projects and solo exhibitions, including "Kitchen Garden," Biennial Exhibition of Public Art, Neuberger Museum of Art, Purchase, New York (1999); "Love Nest," Bird Park, Gallery Joe, Philadelphia (1998); "Memorial," Bard College (1994); "Blackwells," Sculpture Center at Roosevelt Island, New York (1993); "Hidcote," Rosa Esman Gallery, New York (1991); "Sakkara," Socrates Sculpture Park, New York (1987); and the BR Kornblatt Gallery, Washington, D.C. (1983, 1984, 1986). Her group exhibitions include "Timeframes," Albright College, Pennsylvania State University (1997) and "Atmospheric Tension," Prospect Park Boat House, Brooklyn, New York (1990).

SELECTED BIBLIOGRAPHY

*The Nature of Sculpture: Works by Susan Crowder and Patrick Dougherty.* St. Louis: Laumeier Sculpture Park, 1992.

*Susan Crowder: Drawings of the Formal Gardens.* Roslyn, NY: Nassau County Museum of Fine Art, 1984.

*Susan Crowder: The Garden and the Gardener Nurture Each Other.* Easton, PA: Lafayette College, 1994.

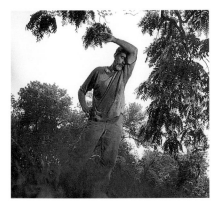

## TIM CURTIS    COCONUT GROVE, FLORIDA

Tim Curtis received his B.A. and M.A. in sculpture from San Diego State University (1974, 1978), and his M.F.A. in sculpture from the University of California, Berkeley, in 1979. He has taught at Washington University, St. Louis; the University of Iowa; and Webster University, St. Louis, and is currently associate professor and head of sculpture at the University of Miami. He has lectured extensively at universities in the United States and abroad and received many grants and awards, among them the Individual Artist Fellowship Grant, Miami (1999) and fellowships from the Bemis Center for Contemporary Arts, Omaha (1994), and the MacDowell Colony (1983). His work can be found in such public collections as Ansung City, South Korea; Cedar Rapids Airport, Iowa; City Museum, St. Louis; Laumeier Sculpture Park, St. Louis; and Skulpturen Park, Katzow, Germany. Curtis's recent solo exhibitions include the Elliot Smith Contemporary Art Gallery, St. Louis (1994, 1996, 1998); Locus Gallery, St. Louis (1986, 1989, 1992); and Quincy Art Center, Illinois (1991). He has also participated in such group exhibitions as "The Third International Symposium," Ichon Cultural Center, Ichon-City, Kyonggi-Do, Korea (2000); "neo-Nomadic," Center for the Cultural Arts, Gadsden, Alabama (2000); "The International Sculpture Exhibition," ARARIO Gallery, Chunahn, South Korea (1999); "Kunst in der Landschaft," Prigglitz, Austria (1998); "Special Projects: Site-Specific Installations," Laumeier Sculpture Park, St. Louis (1998); "Chicago International Exposition," Chicago (1994); "Fantastic Furniture," Cleveland Center for Contemporary Art (1990); and "Design in America," Eastern European Touring Exhibition, United States Information Agency, Washington, D.C. (1986–89).

SELECTED BIBLIOGRAPHY

Bertorelli, Paul. "St. Louis Show, Gateway City Draws Midwest's Best." *Fine Woodworking* 49 (November/December 1984): 87.

*Eighth Rosen Outdoor Sculpture Competition and Exhibition.* Boone, NC: Appalachian State University, 1994.

Pulitzer, Emily Rauh. *Familiar Forms/Unfamiliar Furniture.* St. Louis: First Street Forum, 1984.

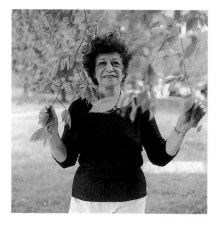

## AGNES DENES  NEW YORK, NEW YORK

Agnes Denes is an American artist and scholar of international renown. Born in Budapest and educated in Stockholm and the United States, she has lectured and taught extensively at universities on four continents and participated in global conferences. Her grants and awards include the Watson Award for Trans-disciplinary Work in the Arts, Carnegie Mellon University (1999); The Rome Prize, American Academy in Rome (1997–98); Honorary Doctorate in Fine Arts, Ripon College (1994); Eugene McDermott Achievement Award, Massachusetts Institute of Technology (1990); Individual Artist Fellowship, National Endowment for the Arts (1974, 1975, 1981, 1990); New York State Council on the Arts grants (1972, 1974, 1980, 1984). She has written many scholarly articles, as well as four books. Her work can be found in public and private collections around the world. Denes has had over thirty solo exhibitions and retrospectives, including the recent "Agnes Denes: Projects for Public Spaces—A Retrospective," Samek Art Gallery, Bucknell University (2002); "The Visionary Art of Agnes Denes," Gibson Gallery, State University of New York, Potsdam (1996); "Agnes Denes" Herbert F. Johnson Museum, Cornell University (1992); and "Master of Drawing," Kunsthalle, Nürnberg, Germany (1982). Her public installations include "Uprooted & Deified—The Golden Tree," Internationella Konstbiennal, Göteborg, Sweden (2001); "Masterplan—Nieuwe Hollandse Waterlinie," The Netherlands (2000–); "A Forest for Australia," Melbourne (1998); "Tree Mountain—A Living Time Capsule", Ylojarvi, Finland (1996); "Art on the Edge," Mitzpe Ramon, Israel (1995); and "Wheatfield—A Confrontation," Battery Park, New York (1992). Her participation in group exhibitions includes The Venice Biennales (1978, 1980, 2001); Museum of Modern Art, New York (1973, 1977, 1993, 1995, 2000, 2001); Museu d'Art Contemporani, Barcelona (2000); Philadelphia Museum of Art (1999); Metropolitan Art Museum, Pusan, Korea (1998); Museum of Contemporary Art, Helsinki (1992); and Musée National d'Art Moderne, Centre Georges Pompidou, Paris (1980).

SELECTED BIBLIOGRAPHY

Barreto, Ricardo. "Sculptural Conceptualism: A New Reading of the Work of Agnes Denes." *Sculpture* 18, no. 4 (1999): cover and 16–23.

Hartz, Jill, ed. *Agnes Denes.* Ithaca, NY: Herbert F. Johnson Museum of Art, Cornell University, Ithaca, 1992. (With essays by Donald Kuspit, Lowery Sims, Robert Hobbs, Peter Selz and Thomas Leavitt)

Kuspit, Donald, "Paradox Perfected—Agnes Denes's Pyramids." In *Idiosyncratic Identities: Artists at the End of the Avant-garde.* New York: Cambridge University Press, 1996.

Selz, Peter. "Agnes Denes: The Visual Presentation of Meaning." *Art in America,* March/April 1975, 72–74.

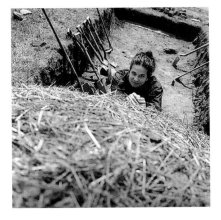

## ROSEMARIE FIORE (b. 1972)   NEW YORK, NEW YORK

Rosemarie Fiore received her B.A. from the University of Virginia (1994) and her M.F.A. from the School of the Art Institute of Chicago (1999). She has taught at The Brooklyn Museum, New York; Virginia Commonwealth University; the University of Virginia; Eastern New Mexico University; and Studio Art Centers International, Florence, Italy; she is currently an adjunct professor at Parson's School of Design in New York. Fiore has received such awards as the Marie Walsh Sharpe Studio Program, New York (2002); Special Editions Fellowship, Lower East Side Print Shop, New York (2002); Roswell Artist-in-Residence Program, RAIR Foundation, New Mexico (2002); Workspace Program Grant, Dieu Donne Papermill, New York (2001); BCAT Fellowship, The Rotunda Gallery, Brooklyn, New York (2001); Anna Louise Raymond Fellowship (1999); and a fellowship from the Skowhegan School of Painting and Sculpture, Maine (1999). Locations of her solo and two-person exhibitions include Body Builder and Sportsman Gallery, Chicago (2002, 2000); Roswell Museum and Art Center, New Mexico (2002); Project Green Brooklyn, New York (2001); Midway Initiative, St. Paul, Minnesota (2001); and Virginia Commonwealth University (2000). Her video screenings include "About the Mind," Video Café, The Queens Museum, New York (2002); "The Dialogue," The Thomas Erbin Gallery, New York (2002); Museo de las Americas, Puerto Rico (2002); Sesto Senso Gallery, Bologna, Italy (2001); "Home Rekkers," JARAF, New York (2001); "The Program," FGA, Chicago, (2001); "Video Spill," Stetson University (2001); and Urban Light Works, Richmond, Virginia (2000). Among her group exhibitions are Silverstein Gallery, New York (2002); "Unmediated Vision," the Salina Art Center, Salina, Kansas (2002); "AIM 21," The Bronx Museum of the Arts, New York (2001); "Uno Spettro d'Immagini," Godwin-Ternbach Museum, Queens College, New York (2001); "Snapshot," The Contemporary Museum, Baltimore (2001); Revolution Gallery, Detroit (1999, 2000, 2001); "Annex," Signal 66 in conjunction with the Corcoran Museum of Art, Washington, D.C. (2000); "Camouflage," LC Bates Museum, Hinkley, Maine (1999); Les Yeux du Monde, Charlottesville (1997, 1998, 1999); and Cool Tan Arts Center, London (1993). Fiore is represented by Body Builder and Sportsman Gallery in Chicago.

SELECTED BIBLIOGRAPHY

*AIM 21.* Bronx, NY: The Bronx Museum of the Arts, 2001, p. 17.

Johnson, Ken. "Newcomers Ready for . . . Creating." *The New York Times,* 10 August 2001, E36.

Protzman, Ferdinand. "Annex at Signal 66." *Washington Post,* 13 April 2000, C5.

## LYDIA CSATO GASMAN (b. 1925)   CHARLOTTESVILLE, VIRGINIA

Lydia Gasman was born in Focsani, Rumania, received her License in Humanities and Law from the University of Bucharest, and studied at the Academy of Fine Art, Bucharest (1950–

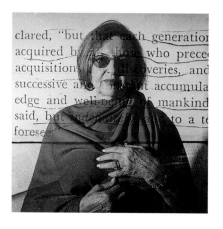

53). She received her M.A. and Ph.D. from Columbia University (1966 and 1981) and has taught as a visiting professor or lecturer at the University of Haifa, the University of Virginia, the City University of New York, and Vassar College. Her Ph.D. thesis, "Mystery, Magic and Love in Picasso 1925–38," generated a revolutionary change in Picasso studies as evident in countless studies on the artist and emphasized in the BBC movie on Picasso *Magic, Love and Death* in which she was featured. She was honored as the foremost Picasso scholar at the opening of "Picasso and the War Years," Solomon R. Guggenheim Museum, New York (1999). She has received an individual Arts Achievement Award, Piedmont Council of the Arts, Charlottesville (1997); Kress Fellowship (1969–70); Woodbridge Fellowship, Columbia University (1968–70); Noble Foundation Fellowship, Columbia University (1967–68, 1966–67); and was awarded full membership in the Rumanian Union of Artists (1953). Her work is included in the public collections of Hadassah Klatzkin Gallery, Tel Aviv, and the Rumanian National Museum, Bucharest. Gasman's solo exhibitions include "Angel of History," Les Yeux du Monde, Charlottesville (2000) and "Landscapes and Portraits of Israel," Hadassah Klatzkin Gallery, Tel Aviv (1961). She has also participated in group exhibitions at the University of Virginia (1982–98); "Lightness," Les Yeux du Monde, Charlottesville (1998); and Washington Square Gallery, New York (1964).

SELECTED BIBLIOGRAPHY

Bernadac, Marie-Laure, and Christine Piot, eds. *Picasso: The Collected Writings.* New York: Abbeville Press, 1989. Pp. xx, xv, 419.

Gasman, Lydia. "Death Falling from the Sky." In *Picasso and the War Years 1937–1945, ed. Steven A. Nash and Robert Rosenblum.* London: Thames and Hudson; San Francisco: Fine Arts Museums of San Francisco, 1998.

———. "Mystery, Magic and Love in Picasso 1925–1938: Picasso and the Surrealist Poets." Ph.D. diss., Columbia University, 1981.

———. "Lydia Gasman on Picasso's Minotaur Series." *Life Magazine,* 27 December 1968, 72–73.

Varnedoe, Kirk. *Picasso: Masterworks from the Museum of Modern Art.* Exhibition catalog. New York: Museum of Modern Art, 1998.

## ANN HAMILTON (b. 1956)  COLUMBUS, OHIO

Ann Hamilton attended St. Lawrence University (1974–76), and received her B.F.A. in textile design from the University of Kansas (1979) and her M.F.A. in sculpture from the School of Art, Yale University (1985). From 1985 to 1991 she taught at the University of California, Santa Barbara, and in 1999 she lectured at the University of Virginia. She is currently a professor at Ohio State University. She has received a number of grants and awards, including the Larry Aldrich Foundation Award (1998); Visual Arts Fellowship, National Endowment for the

Arts (1993); MacArthur Fellowship (1993); Skowhegan Medal for Sculpture (1992); and the Guggenheim Memorial Fellowship (1989). Her work can be found in numerous public collections, including the Solomon R. Guggenheim Museum, New York; Musée d'Art Contemporain, Lyon, France; Museum of Contemporary Art, Chicago; Museum of Contemporary Art, San Diego; Museum of Modern Art, New York; National Gallery of Australia, Canberra; Tate Gallery, London; and the Whitney Museum of American Art, New York. Hamilton's recent solo exhibitions include "at hand," Irish Museum of Modern Art (2002); "the picture is still," Akira Ikeda Gallery, Japan (2001); "myein," Venice Biennale, Italy (1999); "bounden," "mattering," and "Ann Hamilton: Present-Past 1984–1997," Musée d'Art Contemporain, Lyon, France (1997–98); "reserve," Van Abbe Museum, Eindhoven, the Netherlands (1996); "lumen," Institute of Contemporary Art, Philadelphia (1995); Museum of Modern Art, New York (1994–95); "mneme," Tate Gallery, Liverpool (1994); "aleph," MIT List Visual Arts Center, Cambridge, Massachusetts (1992); and "parallel lines," 21st Bienal de São Paulo, Brazil (1991). She has also participated in over fifty group exhibitions, including Sean Kelly Gallery, New York (2000, 1998); Museum of Contemporary Art, San Diego (2000); Carnegie International, Carnegie Museum of Art, Pittsburgh, Pennsylvania (1999–2000, 1991); Trinitätskirche, Cologne, Germany (1999); Venice Biennale, Italy (1997); 10th Biennale of Sydney, Australia (1996); and Spoleto Festival, Charleston (1991).

SELECTED BIBLIOGRAPHY

Pagel, David. "Still Life: The Tableaux of Ann Hamilton." *Arts Magazine* 64 (May 1990): 56–61.

Rogers, Sarah. *The Body and the Object: Ann Hamilton 1984–1996.* Columbus, OH: Wexner Center for the Arts, 1996.

Simon, Joan. *Ann Hamilton.* New York: Harry N. Abrams, Inc., 2002.

———. "Ann Hamilton: Temporal Crossroads," *Art Press* 208 (December 1995): 21–30.

Stewart, Susan. *Ann Hamilton.* La Jolla, CA: San Diego Museum of Contemporary Art, 1991.

## MARTHA JACKSON-JARVIS (b. 1952)  WASHINGTON, D.C.

Martha Jackson-Jarvis attended Howard University (1970–71); received her B.F.A. in sculpture/ceramics from the Tyler School of Art, Temple University (1975); and received her M.F.A. in sculpture/ceramics from Antioch University (1981). She has served as a visiting artist and taught at a variety of universities and institutions. Her grants and awards include Creative Capital Grant, New York (2000); Travel Grant (to American Academy in Rome), Arts International Lila Wallace-Reader's Digest (1994); Grant Award in Sculpture, Penny McCall Foundation (1988); National Sculpture Grant, National Endowment for the Arts (1986); Individual Artist Grant in Sculpture, D.C. Commission on the Arts (1979–80, 1986); and the Emerging Artist Award, Mayor's Art Award, Washington, D.C. (1982). Her work can be found in such public collections as Washington Metro Transit Authority, Anacostia Station, Washington, D.C.; and the Sculpture Garden, Spoleto Festival USA 1997, Charleston. Jarvis-Jackson's solo exhibitions include "Garden Wall: Rue, Rooks, Robin Eggs," Addison-Ripley Fine Art, Washington, DC

(1998); "Structuring Energy," Corcoran Gallery of Art, Washington, DC (1996); BR Kornblatt Gallery, Washington, D.C. (1989, 1991); Franz Bader Gallery, Washington, D.C. (1983); Howard University Gallery of Art, Washington, D.C. (1981); and Washington Project for the Arts, Washington, D.C. (1980). She has also participated in numerous group exhibitions, including "Where Nature and Culture Meet," South Carolina Botanical Garden, Nature Based Sculpture Project 2000, Clemson, South Carolina (2000); "Three Dimensions: Women Sculptors of the '90s," Snug Harbor Cultural Center, Staten Island, New York (1995); and "The Blues Aesthetic," Washington Project for the Arts, Washington, D.C. (1989).

SELECTED BIBLIOGRAPHY

Driskell, David C., ed. *African-American Visual Aesthetic: A Postmodernist View*. Washington, D.C.: Smithsonian Institution Press, 1995.

————. *Contemporary Visual Expressions: The Art of Sam Gilliam, Martha Jackson-Jarvis, Keith Morrison, William T. Williams*. Washington, D.C.: Smithsonian Institution Press, 1987.

Tanguy, Sarah. "Martha Jackson-Jarvis: The Corcoran Gallery of Art." *Sculpture* 15 (October 1996), 60.

Weaver, A. M. "Suspended Metaphors." *International Review of African-American Art* 13 (1996): 32–41.

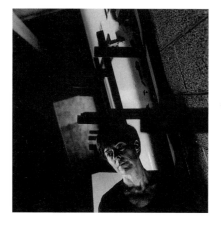

## BARBARA MACCALLUM (b. 1942) CHARLOTTESVILLE, VIRGINIA; NEW YORK, NEW YORK

Barbara MacCallum was born in Belfast, Northern Ireland, received her Diploma in Fine Art from Ulster College of Art and Design (1964), and her M.F.A. from Southern Illinois University (1972). She has taught and lectured at numerous universities and institutions, and from 1980 until 2000 served as a professor of art and Head of Art Program at Piedmont Virginia Community College, Charlottesville. Her grants and awards include the Individual Artist Grant, Ruth Chenven Foundation, New York (1998); Individual Artist Grant, Virginia Commission for the Arts (1990, 1996); and the Artist-in-Residence Grant, National Endowment for the Arts/Southeastern Center for Contemporary Art (1980). Solo exhibitions of her work have been held at 1708 Gallery, Richmond, Virginia (2001); Arlington Arts Center, Virginia (1999); Norteamericano Gallery, Instituto Cultural Peruano, Lima (1997); Anderson Gallery, Virginia Commonwealth University (1995); InterArt Center, New York (1993); and University Art Gallery, Baylor University (1992). She has also participated in a number of group exhibitions, in such locations as White Columns Gallery, New York (traveling exhibition, 2000); Washington Projects for the Arts/Corcoran Museum of Art, Washington, D.C. (1998); Children in Crisis International, Germany (traveling exhibition, 1996); British Crafts Council, London, England (traveling exhibition, 1993–95); Bernice Steinbaum Gallery, New York (1990–94); American Craft Museum, New York; and the Textile Museum, Washington, D.C. (traveling exhibition, 1987–89).

SELECTED BIBLIOGRAPHY

Koplos, Janet. "Structure and Surface: The Work of Barbara MacCallum." *Fiberarts* 10 (March/April 1983): 62–65.

Ryan, Dinah, and Paul Ryan. "The Ambient O: The Twinned Atmosphere of Art and Science," *Art Papers* 23 (January/February 1999): 18–25.

*Transformations: Fiber Orientations/New Applications. The Work of Annet Couwenberg, Barbara MacCallum, and Piper Shepard.* Cortland, NY: Dowd Fine Arts Gallery, State University of New York, 1997.

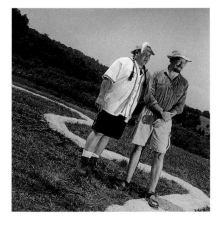

### DAN MAHON (b. 1956)  CROZET, VIRGINIA

Dan Mahon received his A.A.S. in commercial art and graphic design from Thomas Nelson Community College, Hampton, Virginia (1982); his B.F.A. from Davis and Elkins College (1985); his Landscape Design Certificate from George Washington University (1989); and his M.L.A. from the Virginia Polytechnic Institute and State University (1994). He has taught at the Virginia Polytechnic Institute and State University; North Branch School, Afton, Virginia; and the Landscape Design Study Program, Charlottesville. His lectures include "Healing Gardens," Virginia Breast Cancer Conference, Virginia Beach (1999); "Placemaking," Poynter Farm, Stonewall, Virginia (1993); and "Landscape Intervention and Art," Virginia Polytechnic Institute and State University (1992). In 1994, he received the American Society of Landscape Architects Graduate Student Honor Award. Mahon's solo exhibitions include "Power Line," Newport, Virginia (1993) and "Mahon 1973–83," Davis and Elkins College. He has participated in a number of group exhibitions, including "Three Gardens for Transformation" with the Living Earth Design Group, Mallow International Garden and Arts Festival, County Cork, Ireland (1999) and "We Be Three D," Splat Gallery, Norfolk, Virginia (1988). His environmental and site pieces include "Light House Keeping," Grandview Beach, Hampton, Virginia (1989); "25 Poems in Message Bottles," launched from the east and west coasts of the United States (1985–89); and "Often Protected by Horseshoe Crabs" (solo performance), Grandview Beach, Hampton, Virginia (1982). He is also a published poet.

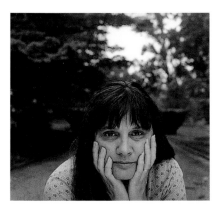

### MEGAN MARLATT  ORANGE, VIRGINIA

Megan Marlatt received her B.F.A. from Memphis College of Art (1981), studied at the Skowhegan School of Painting and Sculpture in Maine (1985), and received her M.F.A. at Rutgers University (1986). She has been an associate professor at the University of Virginia since 1988. She has received a National Endowment for the Arts Individual Artist Fellowship in Painting (1995), and individual fellowships from the Virginia Commission on the Arts (1996) and the New Jersey State Council on the Arts (1985). Marlatt's solo exhibitions include "Art

Nürnberg 8," Festival of the Arts, Germany (1993) and the District of Columbia Arts Center, Washington (1992). Her work has been included in group exhibitions such as "Fresco/Fresh," Educational Alliance Art Gallery, New York (2001); an exhibition curated by Sam Messer at The Painting Center, New York (2000); "A New Naturalism," Snyder Fine Art, New York (1997); "Fresco: A Contemporary Perspective," Boston College Museum of Art (1994); Snug Harbor Cultural Center, Staten Island, New York (1993); and Parson's School of Design, New York (1993). Marlatt's public artwork encompasses a first alternate honor for a New York City Percent for the Arts proposal (2000); a finalist award from the Arts Council of Montgomery County, Maryland (2000); a fresco mural completed for Emmanuel Episcopal Church, Rapidan, Virginia (1996); and site-specific works for Hillwood Museum, Long Island, New York (1993) and the Atlanta Arts Festival (1991).

SELECTED BIBLIOGRAPHY

Crowe, Ann Glenn. "Art Papers." *Objets d'Art*, February 1991.

*Embracing Mysteries.* New York: Souyun Yi Gallery, 1989.

Leiter, Sharon. "Recovering Sacred Spaces: The Art of Megan Marlatt." *Albemarle Magazine*, April/May 1997, 42–49.

Munson, Lynne. *Exhibitionism: Art in an Era of Intolerance.* Chicago: Ivan R. Dee, 2000.

Schwendenwien, Jude. "Cravings: Food into Sculpture." *Sculpture* 11 (November/December 1992): 44–49.

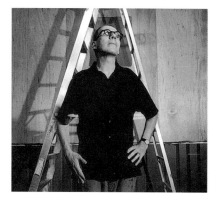

**MICHAEL MERCIL** (b. 1954)   COLUMBUS, OHIO

Michael Mercil attended Saint John's University, Minnesota (1972–74) and received his B.F.A. in intermedia arts from the Minneapolis College of Art & Design (1978) and his M.F.A. in studio art from the University of Chicago (1988). He is currently associate professor in the Department of Art at The Ohio State University and has also taught and lectured at Virginia Commonwealth University, the Minneapolis College of Art and Design, Harvard University, Antioch College, and the University of Minnesota. His grants and awards include a Greater Columbus Arts Council Visual Artists Fellowship (2002); Progressive Architecture Citation Award (with Ann Hamilton and Michael Van Valkenburgh Associates) for Allegheny Riverfront Park, Pittsburgh, Pennsylvania (1997); McKnight Foundation Visual Arts Fellowship (1990); National Endowment for the Arts Artist Design Fellowship (1989); and Jerome Foundation Visual Arts Fellowship, St. Paul (1986). Mercil's solo exhibitions include "promise," the College of Wooster Art Museum (2001); "Real Estate," ISIS Gallery, University of Notre Dame (1997); "Clearings," Olin Gallery, Kenyon College (1995); and "Home Economies," Bockley Gallery, Minneapolis (1992). "Field of Play" and "Ballgame" were commissioned by the Ohio State University Department of Athletics for its football stadium renovation in 2000. His group exhibitions include "Material World," SPACES, Cleveland (1998); "Minnesota Metaphors," Rochester Art Center, Minnesota (1991); "For the Birds," Charles A. Wustum Museum of Fine Arts, Racine, Wisconsin (1990); and "buildingdialogue," Minneapolis Institute of Arts (1989).

SELECTED BIBLIOGRAPHY

Anger, David. "Up Close: Michael Mercil: Social and Urban Histories." *Architecture Minnesota* 19 (March/April 1993): 13, 53.

McEvilley, Thomas. "Hard Questions: One Critic's Reflections." In *Five Jerome Artists.* Minneapolis: Minneapolis College of Art and Design, 1987: n.p.

Mercil, Michael. "Teaching De-design." *Public Art Review* 8, no. 2 (1997): 19–21.

Relyea, Lane. "Public Figures." In *Eight McKnight Artists.* Minneapolis: Minneapolis College of Art and Design, 1991: n.p.

Sutton, Beth. "Environmental Art with a Social Conscience: Five Artists . . ." *64* (Richmond, VA), August 2000, 32–37.

Zurko, Kitty McManus. *Promise: Michael Mercil.* Wooster, OH: The College of Wooster Art Museum, 2001.

## TODD MURPHY (b. 1962)   STAUNTON, VIRGINIA

Todd Murphy attended the University of Georgia from 1982 to 1986. His work can be found in the public collections of the High Museum of Art, Atlanta; McKissick Museum of Art, Columbia, South Carolina; Mint Museum, Charlotte, North Carolina; New Orleans Museum, Louisiana; Tampa Museum of Art, Florida; Georgia Museum of Art, University of Georgia; and the Triton Museum, Santa Clara, California. Murphy's solo exhibitions include "Paintings, Sculpture, and Drawings," The Lowe Gallery, Atlanta, (1990, 1991, 1992, 1994, 1999, 2001); "Art at the Edge: Todd Murphy," High Museum of Art, Atlanta (2000); Haines Gallery, San Francisco (1993, 1994, 1995, 1997); Albany Museum of Art, Georgia (1997); Mississippi Museum of Art, Jackson (1997); Light Factory, Charlotte, North Carolina (1995); and Margulies Taplin Gallery, Coral Gables, Florida (1991, 1994). He has also participated in numerous group exhibitions, including Hidell Brooks Gallery, Charlotte, North Carolina (2000); "Lightness," Les Yeux du Monde, Charlottesville (1998); Georgia Museum of Art, Athens (1997); "Cultured Pearl," Seoul Metropolitan Museum of Art and Seoul Arts Center, South Korea (1996); "Matters of the Heart," Haines Gallery, San Francisco (1996); "Reframing Exposure," Richmond Art Center, California (1995); "Plow," Chassie Post Gallery, New York (1994); "Different Strokes," Guggenheim Gallery, Chapman University, Orange, California (1993); "The Purloined Image," Flint Institute of Arts, Michigan (1993); and the Janice Hunt Gallery, Chicago (1989).

SELECTED BIBLIOGRAPHY

Baker, Kenneth. "Todd Murphy." *ARTnews* 94 (October 1995): 157.

Collins, Bradford R. *Todd Murphy's Heroic Subjectivism.* Columbia, South Carolina: McKissick Museum of Art, 1991.

Cullum, Jerry. "Todd Murphy." *Sculpture* 17, no. 6 (1998): 70–71.

Locke, Donald. "A World Apart: Todd Murphy's 'The New World.'" *Creative Loafing,* 4 November 1995, 33.

McClure, Virginia. "Interview with Todd Murphy." *South Art* 1 (November/December 1994): 6–9.

Murphy, Todd. *Todd Murphy: Paintings, Drawings, Sculpture*. Atlanta: Phoenix Communications, 1995.

## DENNIS OPPENHEIM (b. 1938)   NEW YORK, NEW YORK

Dennis Oppenheim received his B.F.A. from the School of Arts and Crafts, Oakland, California (1965), and his M.F.A. from Stanford University (1966). He has taught at Yale University and the Herron School of Art, Indiana University–Purdue University at Indianapolis. In the 1970s he received fellowships from the National Endowment for the Arts and the Guggenheim Foundation. His work can be found in more than twenty-five public collections across the world, including the Laumeier Sculpture Park, St. Louis; The Metropolitan Museum of Art, New York; Musée d'Art Contemporain, Montreal; National Gallery of Art, Washington, D.C.; San Francisco Museum of Modern Art; Tel Aviv Museum, Israel; Walker Hill Art Center, Seoul, South Korea; and the Whitney Museum of American Art, New York. Oppenheim has had numerous solo exhibitions and retrospectives, including Corcoran Gallery of Art, Washington, D.C. (1999); Museo de Arte Alvar, Mexico City (1998); Venice Biennale (1997); Helsinki City Art Museum, Finland (1997); Rijksmuseum Kröller-Müller, Otterlo, the Netherlands (1982, 1996); MAMCO, Geneva, Switzerland (1996); Palau de la Virreina, Barcelona, Spain (retrospective, 1994); and Pinakotheke Pieride, Athens, Greece (retrospective, 1990). He has also participated in many group exhibitions, including the Joseph Helman Gallery, New York (2000); Galleria Martano, Turin, Italy (2000); Museum of Modern Art, New York (1970, 1993, 1999); Whitney Museum of American Art, New York (1968, 1995, 1998); 24th Bienal de São Paulo, Brazil (1998); 2nd Johannesburg Biennale, South Africa (1998); Centre Georges Pompidou, Paris (1997); inSITE94, San Diego and Tijuana, (1994); Hirschhorn Museum and Sculpture Garden, Washington, D.C. (1984); and the Kunsthalle Düsseldorf, West Germany (1971).

SELECTED BIBLIOGRAPHY

Crockett, Tobey. "Dennis Oppenheim: Stalking the Invisible." *Sculpture* 10 (March–April 1991): 40–47.

Oppenheim, Dennis. "'And the Mind Grew Fingers.'" *Allen Memorial Art Museum Bulletin* 41 (1983–84): 100–111.

Rose, Barbara. *Réalités parallèles: Les dessins de Dennis Oppenheim*. Paris, France: La Différence, 1992.

Thea, Carolee. "Dennis Oppenheim: A Mysterious Point of Entry." *Sculpture* 16 (December 1997): 28–31.

## BEATRIX OST   CHARLOTTESVILLE, VIRGINIA; NEW YORK, NEW YORK

Beatrix Ost was born in Stuttgart, Germany. She studied in Munich: dance at the Isadora Duncan School (1953–59); art at the Academy with Oskar Kokoschka (1958–62); and homeopathy and psychology at the Stachelz-Institut (1968–70). She immigrated to the United

States in 1975, and in 1987 she was artist-in-residence at the New York Academy of Art. Among her awards are the Jury Award for Best Work (Tom Armstrong, juror; 1991) and the Jury Award for Distinction (Donald Kuspit, juror; 1990) from the Peninsula Fine Arts Center in Newport News, Virginia. Her many collectors include the American Health Foundation, Valhalla, New York; Baden-Baden Art Museum, Germany; and the National Museum of Women in the Arts, Washington, D.C. Ost has played many cinematic and literary roles, including producer and creative producer, scriptwriter, actress, author (*I Bit My Tongue, Killer Venus,* and *Hearts' Lonely Hunters*), and book illustrator (Random House). In 1989 she was profiled in a feature documentary, *Zu Gast bei Beatrix Ost,* on ZDF German state television.

Solo exhibitions include "Animal Attraction," Frank Ix Building, University of Virginia Art Museum (2000); Galerie Götz, Stuttgart, Germany (1991, 1994); "Beauty is Harsh," Gallery Whitehall, New York (1993); Second Street Gallery, Charlottesville (1986, 1993); "In Search of the Goddess," Peninsula Fine Arts Center, Newport News, Virginia (1992); and Galerie Rieder, Munich, Germany (1988). Group exhibitions include the New York Academy of Art (1987, 1993, 1994, 1998, 1999, 2001); Peninsula Fine Arts Center (1990, 1991, 1992); Herbstsalon, Haus der Kunst, Munich, Germany (1964); and "Art in Concentration Camps," Museum Baden-Baden, Germany (1961).

SELECTED BIBLIOGRAPHY

Casey, John. *Some Observations on Beatrix Ost's "Beaches and Beds."* Exhibition Catalog. Stuttgart, Germany: Galerie Goetz, 1990.

Holladay, Deborah. *Beatrix Ost.* New York: Riverside Museum Gallery, 1986.

McLeod, Deborah. *In Search of the Goddess.* Newport News, VA: Peninsula Fine Arts Center, 1992.

Riley, Terrence. *The Unprivate House.* New York: Museum of Modern Art, 1999.

**LINCOLN PERRY** (b. 1949)  CHARLOTTESVILLE, VIRGINIA; YORK, MAINE; KEY WEST, FLORIDA

Lincoln Perry received his B.A. (magna cum laude) from Columbia University (1971) and his M.F.A. from Queens College, New York (1975). He teaches part-time at the University of Virginia. He was an assistant teacher at Queens College, and has taught at Caumset Summer Program, Long Island, New York; the University of Arkansas; and the University of New Hampshire. He received a fellowship from the National Endowment for the Arts in 1982. Perry's work can be found in many public and corporate collections, including Becton Dickenson & Co., Paramus, New Jersey; Federal Courthouse, Tallahassee, Florida (mural); Galerie Claude Bernard, Paris; Met Life Building, Metropolitan Square, St. Louis (mural); One Penn Plaza, Washington, D.C. (mural); 1700 Pennsylvania Avenue, The Lincoln Square Building, Washington, D.C. (mural); and the University of Virginia (mural). His solo ex-

hibitions include Lucky Street Gallery, Key West (1997, 1999, 2001); Washington and Lee University Art Museum (1995); Tatistcheff & Co., New York (1982, 1984, 1986, 1988, 1990, 1993); University of Virginia Art Museum (1985); Hildreth Gallery, Nasson College (1980); and Northampton College Gallery, Allentown, Pennsylvania (1979). He has also participated in a number of group shows, including "Lightness," Les Yeux du Monde, Charlottesville (1998); "New American Figure Painting," Contemporary Realist Gallery, San Francisco; Rudolph E. Lee Gallery, College of Architecture, Clemson University (traveling exhibition, 1992); "The Figure in New American Painting and Sculpture," Salon 1990, New York (1990); Academy of Art, New York (1990); and Tatistcheff & Co., New York (1980, 1985, 1986, 1987, 1988, 1989).

SELECTED BIBLIOGRAPHY

Agar, Eunice. "Lincoln Perry." *American Artist,* June 1984, 34–39.

Bolt, Thomas. *Lincoln Perry.* New York: Tatistcheff and Company, 1988.

———. *New American Figure Painting.* San Francisco: Contemporary Realist Gallery, 1992.

———. "Uneasy Answers: Lincoln Perry's Dialectical Narratives." *Arts Magazine* 41 (November 1986): 72–73.

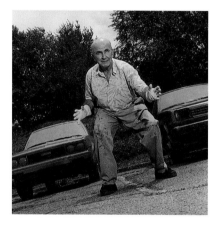

## LUCIO POZZI (b. 1935)   NEW YORK, NEW YORK

Born in Milan, Italy, and an American citizen, Lucio Pozzi has taught at the Tyler School of Art, Maryland Institute of Art, the University of Michigan, Princeton University, and Cooper Union for the Advancement of Science and Art, and participated in the International Summer Seminar at the Center for International Affairs, Harvard University. In 1990, he served as the senior critic at the Graduate Department of Sculpture, Yale University. Since 1978, he has been an instructor in the M.F.A. and B.F.A. programs at the School of Visual Arts, New York. In 1983, he received a National Endowment for the Arts Fellowship. Pozzi's work can be found in the public collections of the Art Gallery of Ontario, Toronto; Detroit Institute of Arts, Michigan; Fogg Museum, Cambridge, Massachusetts; Museum of Contemporary Art, Chicago; Museum of New Art, Detroit; Museum of Modern Art, New York; and the New York Public Library. His most recent solo exhibitions include John Weber, New York (1986, 1996, 2000); Galleria Peccolo, Livorno, Italy (1991, 1999); Studio Carlo Grossetti, Milan (1996); "Arkisex" (performance), Storefront for Art and Architecture, New York (1996); "Lucio Pozzi: American Seventies," Galerie Sabine Wachters, Brussels (1992); "One Pen Drawings," Galerie Albrecht, Munich (1991); "Relentless Waltz" (performance), Paula Cooper Gallery, New York (1991); "Twenty-four Solfeggi for Moscow," Kuznetsky Most and Mars Gallery, Moscow (1991); and "Paperswim" (performance), Dia Center for the Arts, New York (1991). He has also participated in a number of group exhibitions, including "Concurrencies," Grace Borgenicht Gallery, New York (1992); "Out of Site," P.S. 1 Museum, New York (1990–91); "Les Larmes d'Eros," FRAC Centre d'Arts Contemporains, Orléans, France (1989); "Biennale des Friedens," Kunsthaus und Kunstverein, Hamburg (1985); Venice Biennale, American Pavilion (1980); and "Documenta 6," Kassel, Germany (1977).

SELECTED BIBLIOGRAPHY

Heere, Heribert. *Lucio Pozzi: Figurative Malerei.* Munich: Schreiber, 1983.

*Lucio Pozzi.* Mantova: Corraini Editore, 2000.

Pozzi, Lucio. "The Acceptable Apple of Painting." *Tema celeste* 34 (January-March 1992): 70–73.

Siegel, Jeanne. "Lucio Pozzi's 'Mechanisms.'" *Arts Magazine* 54 (May 1980): 174–76.

Van der Marck, Jan. *Lucio Pozzi: Art as Game as Art.* Detroit: Museum of New Art, 2002.

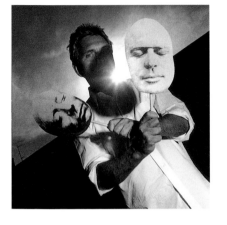

## DANIEL REEVES (b. 1948) EDINBURGH, SCOTLAND; DORDOGNE, FRANCE

Daniel Reeves was born in Washington, D.C., and received his A.S. in Anthropology and his B.S. in Cinema Studies from Ithaca College in 1976. He has served as an artist-in-residence at the University of Virginia; Glasgow School of Art, Scotland; Rocky Mountain Film Center, University of Colorado, Boulder; Harvard University; American Center, Paris; and the School of the Art Institute of Chicago. His grants and awards include the Arts and Humanities Research Board Fellowship, Edinburgh College of Art, Scotland (2000–2003); Scottish Screen Production Grant (1997); John Simon Guggenheim Memorial Media Fellowship (1995); National Endowment for the Arts Fellowships (1980, 1984, 1986, 1987, 1990, 1993, 1994, 1995); and Emmy nominations and three awards in documentary categories (1981, 1995). His work can be found in a number of public collections, including Centre Georges Pompidou, Paris; Musée d'Art Contemporain, Montreal; Museum of Contemporary Art, Los Angeles; Museum of Modern Art, New York; Whitney Museum of American Art, New York; and Stedelijk Museum, Amsterdam, the Netherlands. Reeves's solo exhibitions include the University of Virginia Art Museum (1999); Museum of Modern Art, New York (1996); Video Positive, Liverpool (1995); The Hague, the Netherlands (1995); Institute of Contemporary Art, London (1995); Tate Gallery, Liverpool (1989); and "The Well of Patience," Capp Street Project, San Francisco (1988–89). He has also participated in a number of group exhibitions and screenings, including "Infinitude," Glasgow Museum of Modern Art, Scotland (2000); National Video Festival, American Film Institute, Los Angeles (1982, 1984, 1986, 1987, 1988, 1995); Le Nouveau Festival International du Cinéma, Montreal (1985 [retrospective], 1988, 1995); Edinburgh International Film Festival, Scotland (1987, 1988); 18th Bienal de São Paulo, Brazil (1983); and the Ithaca Video Festival, New York (1979, 1980, 1981).

SELECTED BIBLIOGRAPHY

Christie, Susan. *Daniel Reeves: Jizo Garden.* Scotland: Scottish Arts Council, 1992.

Holboom, Mike, and Karyn Sandlos, eds. *Landscape with Memory.* Toronto: Insomniac Press, 2001.

Rieser, Martin, and Andrea Zapp, eds. *Cinema/Art/Narrative.* London: British Film Institute, 2002.

Zimmermann, Patricia R. "Processing Trauma: The Media Art of Daniel Reeves." *Afterimage* 26 (September/October 1998): 11–13.

———. *States of Emergency: Documentation, Wars, Democracies*. Minneapolis: University of Minnesota Press, 2000.

Forthcoming monograph on Daniel Reeves with contributions by Linsay Blair, Malcolm Dickson, and Patricia Zimmermann.

## JAMES WELTY (b. 1952)   CHARLOTTESVILLE, VIRGINIA

James Welty attended the School of the Art Institute of Chicago (1969), and the Ruskin School of Drawing, Oxford (1973); he received his B.F.A. (summa cum laude) from the Rochester Institute of Technology, New York (1974). He has served as a lithography instructor at the Evanston Art Center, Illinois (1969), and in 1975 received the Artists' Guild Purchase Prize, Chicago. Welty's solo exhibitions include Davis & Hall Gallery, Hudson, New York (2000, 2001); Sterne Foundation, East Hampton, New York (1998); and John Davis Gallery, New York (1987, 1989). He has also participated in a number of group exhibitions, including Davis & Hall Gallery, Hudson, New York (1999); S. O. F. A. International, Chicago (1997); Gallery of Functional Art, Santa Monica, California (1992–95); Renee Fotouhi Fine Art, New York (1992–95); David Sutherland, Dallas (1992–95); Calvin & Lloyd Art, Norfolk, Virginia (1992–95); C. I. T. E. Design, New York (1992–94); John Davis Gallery, New York (1986, 1989, 1990); Aldrich Museum of Art, Ridgefield, Connecticut (1988); "Novo Arts Group Show," New York (1983); and Eighth British Invitational Print Biennial, Bradford, England (1983).

SELECTED BIBLIOGRAPHY

Anderson, Jack. "Performing at the Kitchen." *New York Times,* 13 April 1992, Arts section.

Blair, Elizabeth. "Events," *Sculpture* 6 (September/October 1987): 47.

Henry, Gerrit. "James Welty at John Davis." *Art in America* 78 (March 1990): 204.

Mennckes, Friedhelm. "Interview with James Welty." *Kunst und Kirche,* April 1987, 288–91.

Raynor, Vivien. "Photos and Sculpture at the Aldrich." *New York Times,* 27 November 1989, sec. CN, p. 40.

Scott, Martha B. *Innovations in Sculpture 1985-1988.* Ridgefield, CT: Aldrich Museum of Art, 1988.

Toepp, Wayne. "The Dissected Muse: James Welty's Recent Constructions." *Arts Magazine* 62 (September 1987): 70–71.

## PETER O'SHEA   CHARLOTTESVILLE, VIRGINIA

Peter O'Shea (pictured with Winstead; O'Shea to the right) received his B.A. in fine art from Bates College in Lewiston, Maine (1988) and a Master of Landscape Architecture degree from the University of Virginia (1993). Since 1997, he has served as an assistant professor in the Department of Landscape Architecture at the University of Virginia. He has lectured at the University of Oregon; Ohio State University, Division of Landscape Architecture; and the University of Pennsylvania Graduate School of Fine Arts. He is the cofounder of O'Shea/Wilson Siteworks, Charlottesville, and previously worked for Nelson/Byrd Landscape Architects, Charlottesville (1997–2000).

O'Shea has received a number of grants and awards, including the place of First Honorable Mention in the 13-Acres International Design Competition (2001); winning entry for "The Community Chalkboard," sponsored by the Thomas Jefferson Center for the Pro-

tection of Free Expression and the City of Charlottesville (1998); and a Rome Prize Fellowship in Landscape Architecture, American Academy in Rome (1995). His exhibitions include "The Community Chalkboard," Thomas Jefferson Center for the Protection of Free Expression, Charlottesville (2000); Greenport Waterfront International Design Competition Exhibition, Van Alen Institute, New York (1997); "Marrana Mariana," Cryptoporticus Gallery, American Academy in Rome (1996); "casa tua e' casa mia," American Academy in Rome (1996); "L'Architecture di mostra," Architettura Arte Moderna, Rome, Italy (1996); "New Parks: New Ideas," The Urban Center, New York (1992); and "Art about the War," Fayerweather Gallery, McIntire Department of Art, University of Virginia (1992).

SELECTED BIBLIOGRAPHY

Bennett, Paul. "Deeper than Art" and "Reusing On-site Materials." *Landscape Architecture Magazine* 89, no. 6 (1999): 22–28.

———. "Worlds Apart." *Landscape Architecture Magazine* 90, no. 8 (2000): 60-69, 82–87.

"In Va. Town, Free Speech Hits a Wall." *Washington Post*, 11 February 2001, p. 1.

"Nation Reacts to Chalkboard Idea." *Charlottesville Daily Progress*, 26 February 2001, p. 1.

O'Shea, Peter, and Philip Beesley. "Marrana Mariana." *Land Forum* 6 (2000): 50–52.

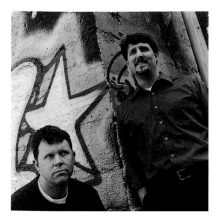

## ROBERT B. WINSTEAD CHARLOTTESVILLE, VIRGINIA

Robert Winstead (pictured left) studied at the Program of Architecture in Vicenza, Italy (1990), and received his B.S. in Architecture at the University of Virginia (1991) and his Master of Architecture at the Graduate School of Design, Harvard University (1997). In 1999 he served as a design instructor in the School of Architecture, University of Virginia. Winstead has lectured at Building Virginia 2000, Richmond (2000); Mainstreaming Green Conference, Chattanooga (1999); and Environmental and Economic Balance: The 21st Century Outlook, Miami (1997). Since 1998 he has worked as a Project Architect at VMDO Architects, PC, Charlottesville.

In 1998, "The Community Chalkboard" was the winning entry in the Design Competition for a Monument to Free Expression, sponsored by The Thomas Jefferson Center for the Protection of Free Expression and the City of Charlottesville. In 1999, he designed and organized a land art installation in Charlottesville called "PARK! A Vision of Greenspace in an Asphalt Culture." Photographs of the installation, by photographer Alexandria Searls, have been included in the following exhibits: "Millennium Time Capsule," The University Gallery, University of Bridgeport (Juror: Harry Philbrick, the Aldrich Museum of Contemporary Art; 2000); "Art for Environmental Advocacy," Adell McMillan Gallery, University of Oregon (2000); "Preserving the Garden: Saving the New Jersey Landscape," Printmaking Council of New Jersey, Somerville (2000); "National Juried Show 2000," Art Center of Northern New Jersey, New Milford (Juror: Melanie Marino, Guggenheim Museum of Art); "Biennial 2000," Peninsula Fine Arts Center, Newport News, Virginia, Award of Recognition (2000); McGuffey Art Center, Charlottesville (1999). Exhibits of his architectural design work include "Student Work Exhibition," Graduate School of Design, Harvard University (1996); and "Visions of Home," National Building Museum, Washington, D.C. (1994).

# NOTES ON THE ESSAYISTS

JOHN BEARDSLEY teaches in the Department of Landscape Architecture at the Harvard Design School. He is the author of several books on art and landscape, including *Earthworks and Beyond* (third edition, 1998) and *Gardens of Revelation: Environments by Visionary Artists* (1995). He has organized numerous exhibitions of contemporary art, among them "Black Folk Art in America" (Corcoran Gallery of Art, 1982) and "Hispanic Art in the United States" (Museum of Fine Arts, Houston, 1987). His most recent project, "The Quilts of Gees Bend," presents the textiles of a small African American community on the Alabama River (Museum of Fine Arts, Houston, and Whitney Museum, New York, 2002).

JOHN T. CASTEEN III became president of the University of Virginia in August 1990. From 1975 to 1982, he served as the University's dean of admissions. After teaching English at the University of California, Berkeley, and the University of Virginia, Mr. Casteen became Virginia's secretary of education in 1982, and served until 1985. From 1985 to 1990, he was president of the University of Connecticut.

Mr. Casteen writes short fiction as well as essays and papers on medieval literature, bibliography, and public policy. A collection of his short stories received the 1987 Mishima Award for fiction.

LUCIA STANTON first came to Jefferson's mountaintop in the late 1960s and has been fascinated by its natural features and its human history ever since. She spent eight years as Monticello's director of research and has been, since 1996, Shannon Senior Research Historian there. Her major introduction to the world of Monticello was as coeditor, with James A. Bear Jr., of *Jefferson's Memorandum Books*, a sixty-year record of his expenditures. She has written articles on slavery and Jeffersonian science and travel, and is the author of *Free Some Day: The African-American Families of Monticello*.

PETER S. ONUF, Thomas Jefferson Memorial Foundation Professor in the Corcoran Department of History at the University of Virginia, specializes in the history of the early American republic. Educated at Johns Hopkins University, where he received his Ph.D. in 1973, Onuf taught at Columbia University, Worcester Polytechnic Institute, and Southern Methodist University before coming to Virginia in 1990. His recent work on Thomas Jefferson's political thought, culminating in *Jefferson's Empire: The Language of American Nationhood* (University of Virginia Press, 2000), grows out of his earlier studies on the history of American federalism, foreign policy, and political economy.

LYN BOLEN RUSHTON curated the "Hindsight/Fore-site" exhibition for the University of Virginia Art Museum in the summer of 2000. She also organized the exhibition "Movement and Meaning: Images of Dance in Early Modernist Art" in 1996, based on her Ph.D. dissertation at the University of Virginia. She is currently the owner and director of the Les Yeux du Monde gallery in Charlottesville.

JILL HARTZ has served as director of the University of Virginia Art Museum since 1997 and previously worked at the Herbert F. Johnson Museum of Art, Cornell University, for ten years. She has curated numerous exhibitions, including a 2003 show on contemporary Irish art, and served as editor of an Agnes Denes monograph.